THE
DEATH
OF
Archie ®

Published by Archie Comic Publications, Inc.
325 Fayette Avenue, Mamaroneck, New York 10543-2318.

Printed in Canada.

ISBN: 978-1-62738-982-2

FIRST PRINTING.

Publisher / Co-CEO: Jon Goldwater
Co-CEO: Nancy Silberkleit
President: Mike Pellerito
Co-President / Editor-In-Chief: Victor Gorelick
Chief Creative Officer: Roberto Aguirre-Sacasa
SVP – Sales & Business Development: Jim Sokolowski
SVP – Publishing & Operations: Harold Buchholz
SVP – Publicity & Marketing: Alex Segura
Executive Director of Editorial: Paul Kaminski
Production Manager: Stephen Oswald
Project Coordinator & Book Design: Joe Morciglio
Proofreader/Editorial Assistant: Jamie Lee Rotante
Additional Written Content: Alex Segura & Jamie Lee Rotante

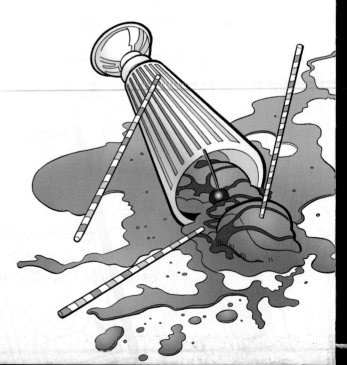

Written by
Paul Kupperberg

Pencils by
**Pat Kennedy, Tim Kennedy
and Fernando Ruiz**

Inks by **Jim Amash, Bob Smith
and Gary Martin**
Lettering by **Jack Morelli**
Coloring by **Glenn Whitmore**

Cover Art by **Jeff Shultz**
Cover Rendering by **Tito Peña**

Based on the
Archie Wedding Series
originated by Michael Uslan

THE BEGINNING OF AN END

Archie Andrews died as he lived—helping his friends, and showing the bravery and heart that we all hope is inside each of us.

The climactic finale of LIFE WITH ARCHIE, which you are about to read, is an ending—but not the end for the character who's brought joy to millions around the world for almost 75 years. But it does signal the final chapter of one of the company's most critically-acclaimed series in LIFE WITH ARCHIE. Archie's heroic sacrifice in the face of a danger that many have faced in reality reiterates his role as a true everyman at any age. Archie is one of us—and one of the best, giving us all something to strive for. His final moments in the pages of LIFE WITH ARCHIE #36 is just the latest example of this.

While the issue is far from a happy affair, it does allow us—and in Riverdale, his own friends—the chance to celebrate the character and friend that we've come to know for all our lives. From the funny to the poignant, the issue not only presents Archie as a hero, but also shows us how the many important people that have filled his life see him: a friend, husband, teammate and colleague. Sometimes it's through absence that we truly realize how important something or someone is, as the second half of this story shows.

This ending also provides a rare opportunity in terms of characters with this kind of pop culture longevity—a chance to look back, to the beginning. Here, we meet Archie co-founder John L. Goldwater, who wanted to tell a story about an everyman teenager caught up in an ongoing, teenage love triangle. With those notes and more, he tasked young cartoonist Bob Montana with bringing his vision to life. Thus, Archie was born and comics—and entertainment—would never be the same.

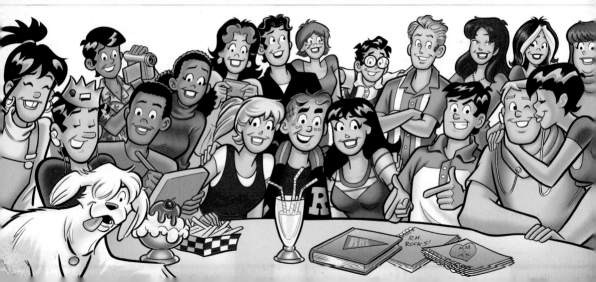

FOREWORD

LIFE WITH ARCHIE started back in 2010, following the hit "Will You Marry Me?" storyline, which I worked on with Michael Uslan. At the time, I thought the idea of Archie getting married was crazy, but the more I thought about it, the more I realized it was a really good idea. Some people were upset when they thought that Archie was only proposing to one of the girls, which was why it was so important to create two realities where he marries them both. How did that happen? It all started when Archie took a walk up Memory Lane.

In my over fifty years of working at Archie, I've seen a lot of changes. We always try to keep up with the times and, especially in recent years, we've come up with some new things and a lot of big moves with the books, such as the creation of Kevin Keller. Introducing a gay teenager into the Riverdale family was huge. It was very big and very well received. It made sense that this character, who, in LIFE WITH ARCHIE, has become a bona fide hero, be the one who is saved by Archie. It has also been a great pleasure working with Jon Goldwater, who has not only shepherded in these important changes as well as this specific storyline, but also whose vision of the Archie universe is ever-expanding.

So, why does Archie have to die? It's not because Riverdale has changed, or that the fundamental basics of what made Archie great have been altered—what's changed is reality. We have done some stories over the years that have dealt with bullying or other problems that kids might have in school, but never anything dealing with something like this. We've always said that Archie is a typical teenager—but in LIFE WITH ARCHIE he is a typical adult and, for better or for worse, has to face "adult" problems head on.

Yes, in LIFE WITH ARCHIE, Archie Andrews dies. It's a sad ending, but comic books are still here and Archie will live on in our comics, digests, graphic novels, digitally and in the not too distant future, TV and the movies. So wipe away your tears, Archie's still here and will be for years to come.

- Victor Gorelick,
Co-President / Editor-in-Chief

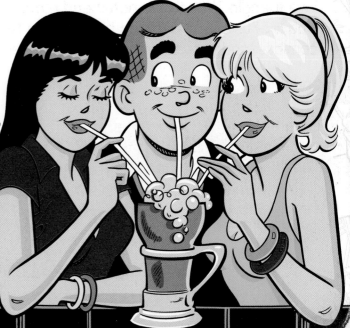

THE DEATH OF Archie®

A MESSAGE FROM THE PUBLISHER

I'd like to tell you a story...

You see, I grew up with Archie and his friends. My father was on the ground floor of everything in relation to the character—Archie literally sprung from his mind onto the page! These characters were more than just artwork on a page to me. They were lifelong family I now get to see every day. I wanted everyone to know Archie—and what he stands for.

Archie, as a character and as a brand, has run parallel to the story of our country. From the final days of the Great Depression to the culture wars of the modern day, Archie has represented the best we have to offer: kindness, bravery, honesty and friendship. Sure, he stumbles and makes mistakes—don't we all? But despite a few pratfalls, his heart is in the right place. He is the best of us.

The story today, five years later, "What will Archie do next?" People know the brand. They know the character and his world and they expect the unexpected.

It started with the wedding and continued to LIFE WITH ARCHIE. The introduction of the first gay character in Archie comics, Kevin Keller, showed the world we were changing.

His future marriage in the pages of LIFE WITH ARCHIE reiterated it. We were the first company to fully embrace digital comics and expand our reach to anyone with a tablet or computer. The company is more vibrant than ever. In fact, words like "progressive" and "innovative" are likely to accompany mentions of the brand. We challenge our critics and aim for the stars. All in the quest to tell a great story and entertain our legion of fans.

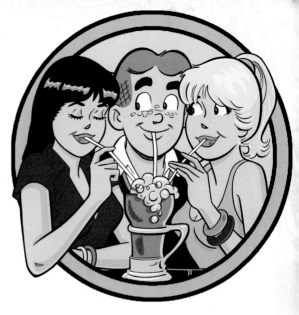

At Archie Comics, there are no limits and there are no rules beyond the basic ones I laid out to my staff and supremely talented writers and artists when I started: Make Riverdale feel like a city in America today—reflective of our world. Keep our characters flexible and durable and stay true to what they've always been.

Today we have a twenty something Archie at the center of an acclaimed, serialized drama series. We have a teenage Archie leading a band of friends against a zombie apocalypse. We will have iterations of Archie across all media in the coming years. We will always have the classic teenage humor and slapstick that this company was built on—a legacy I carry with me that my father and his two co-founders began and a responsibility I take so very seriously, and with respect and joy.

Archie is everywhere.

Jon Goldwater
Publisher / Co-CEO

OUR STORY SO FAR...

LIFE WITH ARCHIE tells the tale of two futures for everyman Archie Andrews: one where he's married to lovable girl-next-door Betty Cooper and another where he's married socialite Veronica Lodge. Both stories—under the sub-headers "Archie Marries Betty" and "Archie Marries Veronica"—were told separately in the pages of LIFE WITH ARCHIE magazine and conclude in the book you now hold in your hands.

But let's start from the top...

Though their lives are significantly different, both the "Archie Marries Veronica" (AMV) and "Archie Marries Betty" (AMB) universes have a few things in common, including:

Mr. Lodge is business partners with the evil tycoon Fred Mirth, who secretly has an agenda all his own. Dilton returns to Riverdale and conducts secret meetings with both men. It turns out that when they were in college, Mirth stole several of Dilton's scientific plans.

Also, in an effort to prevent the Chocklit Shoppe from closing, Jughead takes over with the help of his new girlfriend, Midge.

"AMV" starts with the newlyweds working for Lodge Industries. Meanwhile, Mr. Lodge and Fred Mirth are buying out all of Riverdale's local shops. Moose and Midge break up due to his anger issues. He finds peace through meditation then later becomes Mayor. Jughead—overwhelmed with running the newly-franchised Chocklit Shoppe disappears, putting more stress on Midge. She ends her relationship with Jughead. He starts dating Ethel and they later get married.

"AMB" begins with the couple moving back to Riverdale from NYC after Archie's music career stalls. Mr. Weatherbee marries Ms. Grundy, but she soon after succumbs to cancer. Archie and Betty then accept jobs as teachers at Riverdale High, with Archie teaching Music and Betty teaching English. Moose Mason also joins the ranks of Riverdale High Alumni now working at their alma mater as the new janitor. Midge and Jughead are married and have welcomed a baby boy to the world!

Archie's childhood pal Ambrose Pipps has been recruited by the "Good" Dilton of the AMB future to unite the two alternate timelines and save the day. He brings the two Archies, along with the AMB Reggie, to Memory Lane. The "Evil" Dilton from AMV was building something called a "Super Collider," that Fred Mirth got his hands on and was planning on using on the entire universe for sinister purposes. Fortunately, the Mr. Lodge of the AMB future built a failsafe device under Riverdale High in case the "Super Collider" had gone off. Moose, along with "Good" Dilton's help, destroys the super collider—erasing everyone's memories of the event! While this is taking place, Reggie and Archie are deemed missing in a "mine collapse," worrying everyone. When Archie returns safely in AMV, he and Veronica are reunited and put their rocky past behind them.

In AMV, Fred Mirth offers Archie a job as the head of a music label and Veronica quits Lodge Industries to start her own company, but she is framed by Mirth for corruption and is later arrested. Meanwhile, Betty and Reggie begin dating. Reggie opens his own antique motors shop, while Betty starts her own catering business. Reggie pitches a reality show to a TV producer about his life and relationship with Betty, which debuts at the cost of the couple's privacy.

In AMB, Archie begins to resent Betty's increasing responsibilities at school—where she's been promoted to Interim Assistant Principal, and he starts hanging out with Bella Beazly, Ms. Beazly's daughter and the new cafeteria cook at Riverdale High—who kisses him. Reggie and Veronica start dating, but the two manage to find a good balance between their relationship and their busy schedules.

In both universes, Kevin Keller returns to Riverdale after being injured during his tour of duty in the Middle East. Upon his return, he falls in love with, and later marries, his physical therapist, Clay Walker.

While attempting to stop a robbery, Clay is shot. He survives, and the event gets Kevin thinking about the nation's lax gun laws, and he decides to run for Senate!

A shooter later targets gay employees in an attack at the nearby Southport Mall, fueling Kevin's campaign for Senate on an anti-gun platform.

He wins the election, but his views have hurtled him into the spotlight—and not everyone agrees with his legislative plans.

In AMB, Jughead's sister, Jellybean, starts working at the Chocklit Shoppe and begins dating a mysterious stranger, who appears to be the cause of a string of robberies in Riverdale, until Jellybean turns him in after tries to rob the Chocklit Shoppe.

In both universes, the Chocklit Shoppe has endured the test of time and hosted the weddings of Mr. Weatherbee and Ms. Grundy, Svenson and Ms. Beazly, Jughead and Midge, Jughead and Ethel, the party for the debut of TV's "Betty Loves Reggie," and it will now serve as the after party location for Kevin's Southport fundraiser.

In AMB, Cheryl Blossom returns to Riverdale where she reveals her battle with a severe form of breast cancer. Veronica helps Cheryl out, holding a benefit concert at the newly-opened Chowhouse II. The fundraiser proves to be successful and she starts her own breast cancer awareness foundation.

All of these events bring us to the grand finale of LIFE WITH ARCHIE. Archie's final moments and the celebration of his life afterward are arguably the most poignant and engaging stories in a series full of wonderful, historic and dramatic moments. Read as a whole, it serves as the perfect coda to an epic tale of friendship, love, loss and humanity. Even read alone, it gives the reader a sense of what a trailblazing series LIFE WITH ARCHIE has been.

Turn the page and prepare for the final chapters of the life of Archie.

"IT WAS TIME TO COMMIT TO THE PROMISE I'D MADE..."

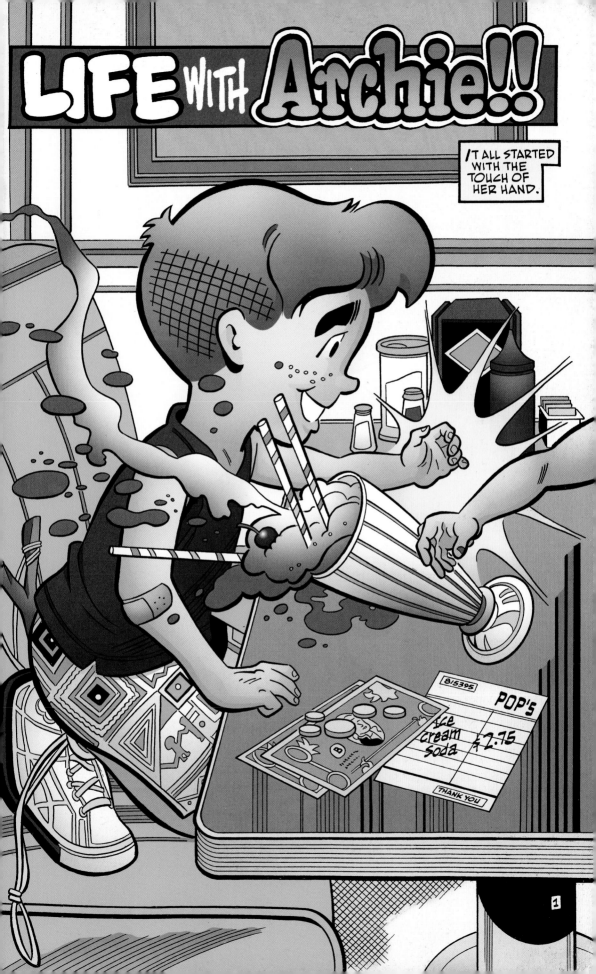

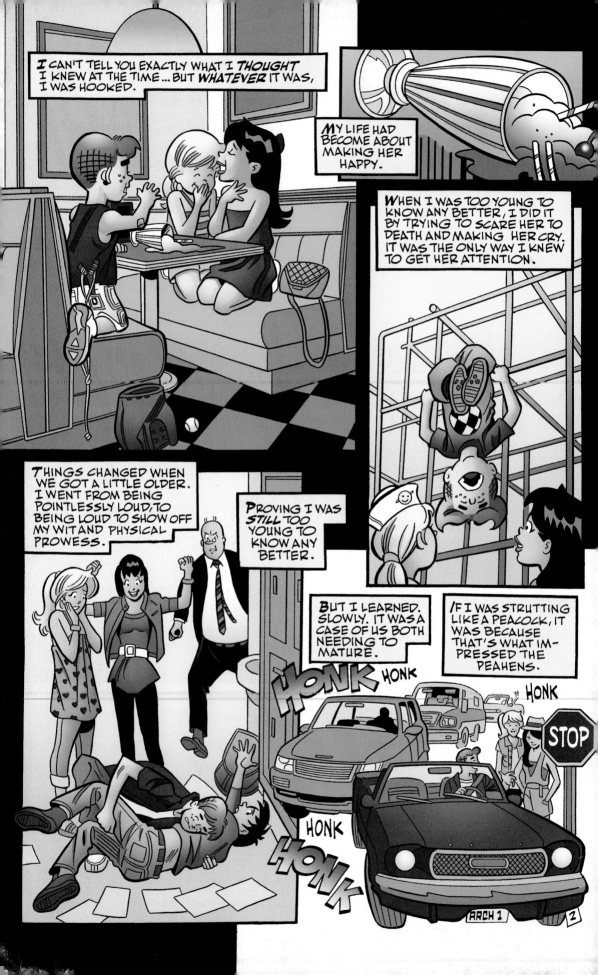

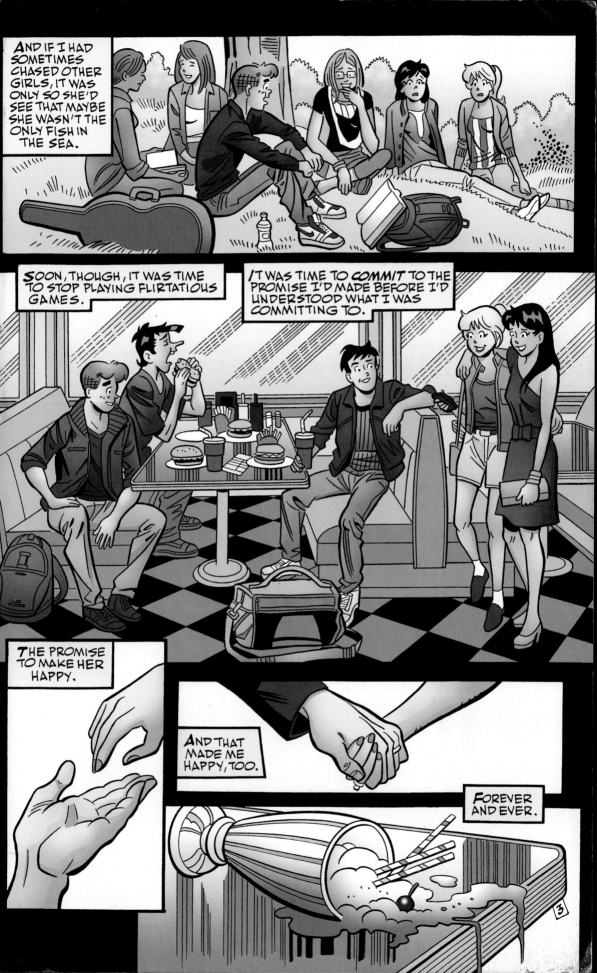

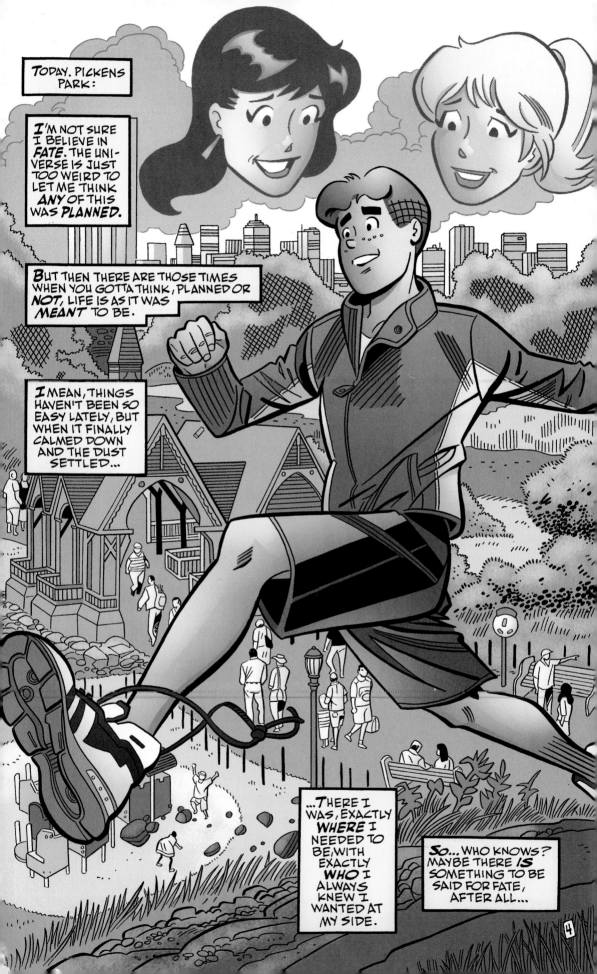

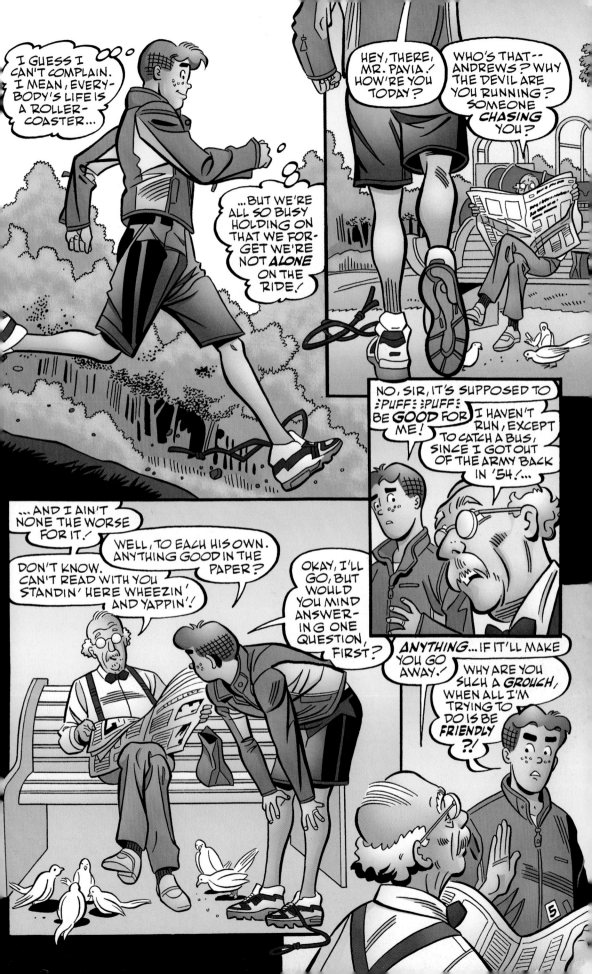

I GUESS I CAN'T COMPLAIN. I MEAN, EVERYBODY'S LIFE IS A ROLLER-COASTER...

...BUT WE'RE ALL SO BUSY HOLDING ON THAT WE FORGET WE'RE NOT *ALONE* ON THE RIDE!

HEY, THERE, MR. PAVIA! HOW'RE YOU TODAY?

WHO'S THAT-- ANDREWS? WHY THE DEVIL ARE YOU RUNNING? SOMEONE *CHASING* YOU?

NO, SIR, IT'S SUPPOSED TO :PUFF: :PUFF: BE *GOOD* FOR ME!

I HAVEN'T RUN, EXCEPT TO CATCH A BUS, SINCE I GOT OUT OF THE ARMY BACK IN '54!...

...AND I AIN'T NONE THE WORSE FOR IT!

WELL, TO EACH HIS OWN. ANYTHING GOOD IN THE PAPER?

DON'T KNOW. CAN'T READ WITH YOU STANDIN' HERE WHEEZIN' AND YAPPIN'!

OKAY, I'LL GO, BUT WOULD YOU MIND ANSWERING ONE QUESTION, FIRST?

ANYTHING...IF IT'LL MAKE YOU GO AWAY!

WHY ARE YOU SUCH A *GROUCH*, WHEN ALL I'M TRYING TO DO IS BE *FRIENDLY*?!

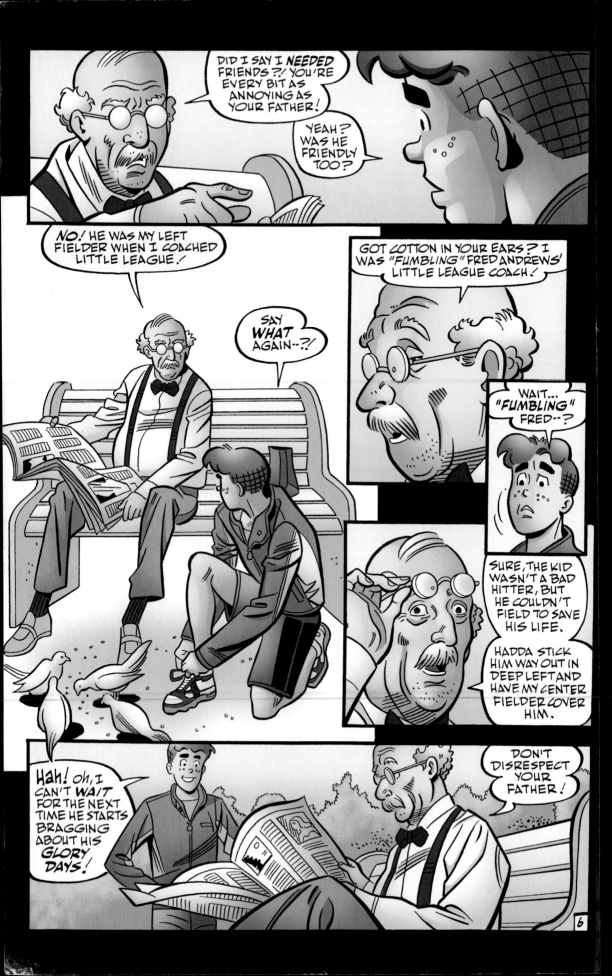

DID I SAY I **NEEDED** FRIENDS?! YOU'RE EVERY BIT AS ANNOYING AS YOUR FATHER!

YEAH? WAS HE FRIENDLY TOO?

NO! HE WAS MY LEFT FIELDER WHEN I COACHED LITTLE LEAGUE!

SAY **WHAT** AGAIN--?!

GOT COTTON IN YOUR EARS? I WAS "FUMBLING" FRED ANDREWS' LITTLE LEAGUE COACH!

WAIT... "FUMBLING" FRED--?

SURE, THE KID WASN'T A BAD HITTER, BUT HE COULDN'T FIELD TO SAVE HIS LIFE.

HADDA STICK HIM WAY OUT IN DEEP LEFT AND HAVE MY CENTER FIELDER COVER HIM.

Hah! OH, I CAN'T **WAIT** FOR THE NEXT TIME HE STARTS BRAGGING ABOUT HIS **GLORY DAYS!**

DON'T DISRESPECT YOUR FATHER!

6

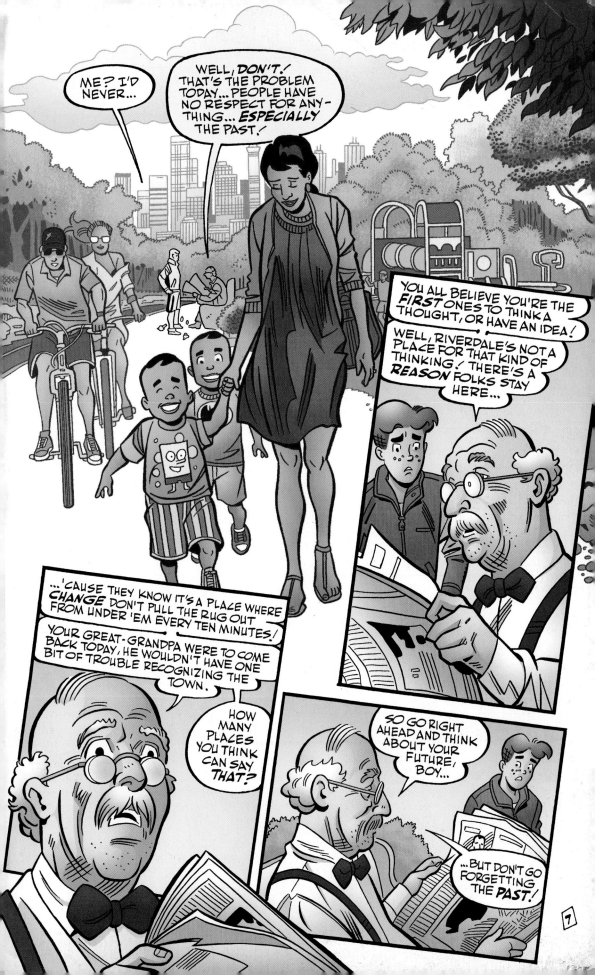

ME? I'D NEVER...

WELL, *DON'T!* THAT'S THE PROBLEM TODAY... PEOPLE HAVE NO RESPECT FOR ANY-THING... *ESPECIALLY* THE PAST!

YOU ALL BELIEVE YOU'RE THE *FIRST* ONES TO THINK A THOUGHT, OR HAVE AN IDEA!

WELL, RIVERDALE'S NOT A PLACE FOR THAT KIND OF THINKING! THERE'S A *REASON* FOLKS STAY HERE...

...'CAUSE THEY KNOW IT'S A PLACE WHERE *CHANGE* DON'T PULL THE RUG OUT FROM UNDER 'EM EVERY TEN MINUTES!

YOUR GREAT-GRANDPA WERE TO COME BACK TODAY, HE WOULDN'T HAVE ONE BIT OF TROUBLE RECOGNIZING THE TOWN.

HOW MANY PLACES YOU THINK CAN SAY *THAT?*

SO GO RIGHT AHEAD AND THINK ABOUT YOUR FUTURE, BOY...

...BUT DON'T GO FORGETTING THE *PAST!*

uh.

NO, SIR, I WON'T.

SO... I'LL SEE YOU AROUND, MR. P.! TAKE IT EASY.

Hmph!

JUST LIKE HIS FATHER.

I GUESS MAYBE THERE *IS* HOPE FOR THIS GENERATION AFTER ALL!

"THINK ABOUT YOUR FUTURE," MR. PAVIA SAID...

I'VE BEEN SO BUSY SWEATING MY *PRESENT* PROBLEMS THAT I HAVEN'T GIVEN MUCH THOUGHT TO WHAT'S AHEAD.

IT FEELS LIKE ONLY YESTERDAY WE WERE IN HIGH SCHOOL... BUT BACK THEN, *ONLY* THE *NOW* MATTERED.

I DOUBT IF I EVER EVEN CONSIDERED BEING WHERE I AM TODAY...

MEMORY LN.

8

STILL...WHEN I WAS A KID, I USED TO DREAM ABOUT ONE DAY GETTING OUT OF RIVERDALE AND SEEING THE WORLD.

I COULDN'T IMAGINE SPENDING THE REST OF MY LIFE HERE.

I THOUGHT I WOULD BE A BUSINESSMAN LIKE MR. LODGE...

...AND ALWAYS WONDERED WHY HE STAYED PUT WHEN HE COULD LIVE ANYWHERE IN THE WORLD.

BACK THEN, I THOUGHT THAT IF I WAS AS RICH AS HIM, I'D BE OUT OF HERE SO FAST I'D MAKE HEADS SPIN...

...THIS WAS JUST A QUICK STOPOVER TO VISIT MY PARENTS. I'M BOARDING THE PLANE NOW AND WILL BE IN CHICAGO IN A FEW HOURS.

I'LL EXPECT TO SEE THOSE CONTRACTS BEFORE I LAND!

12

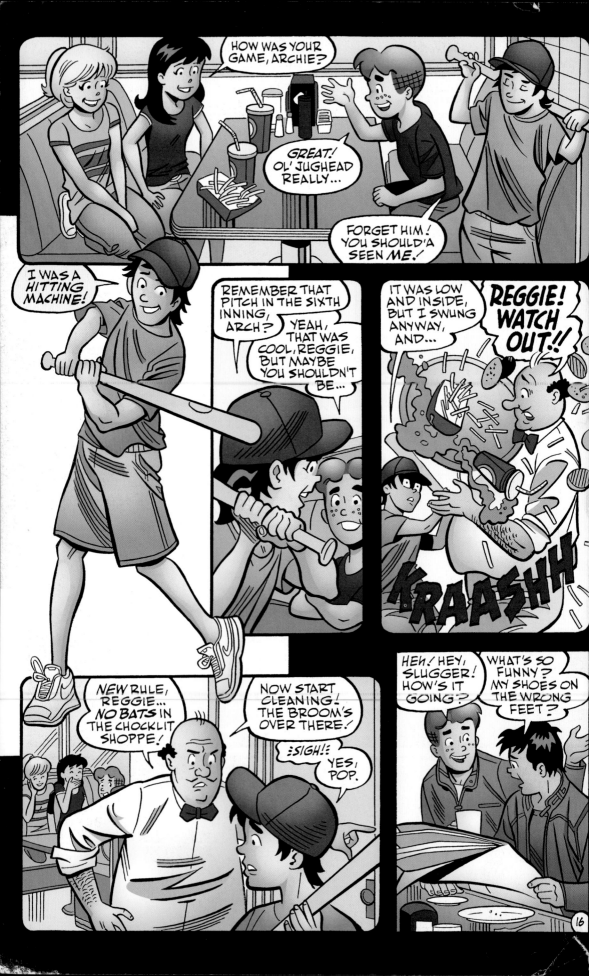

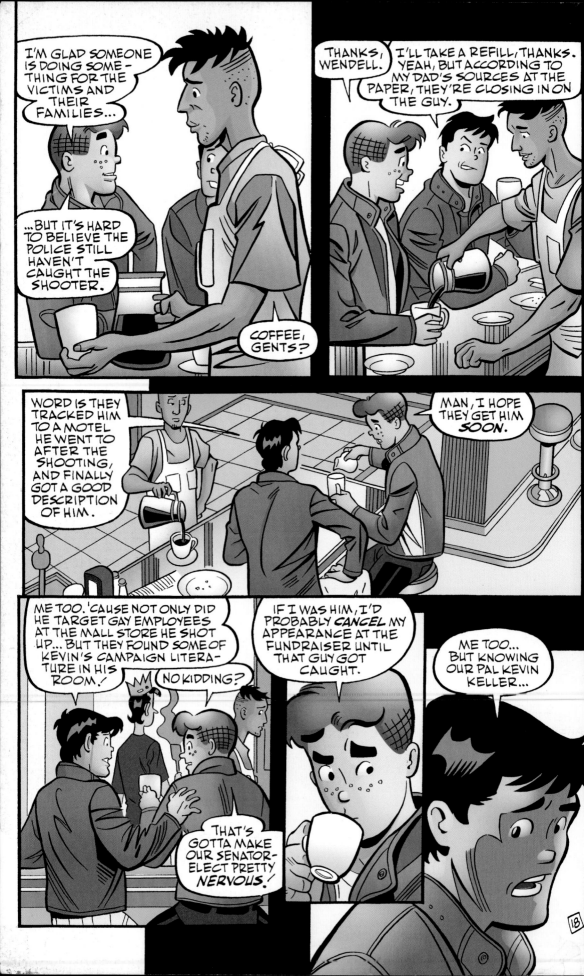

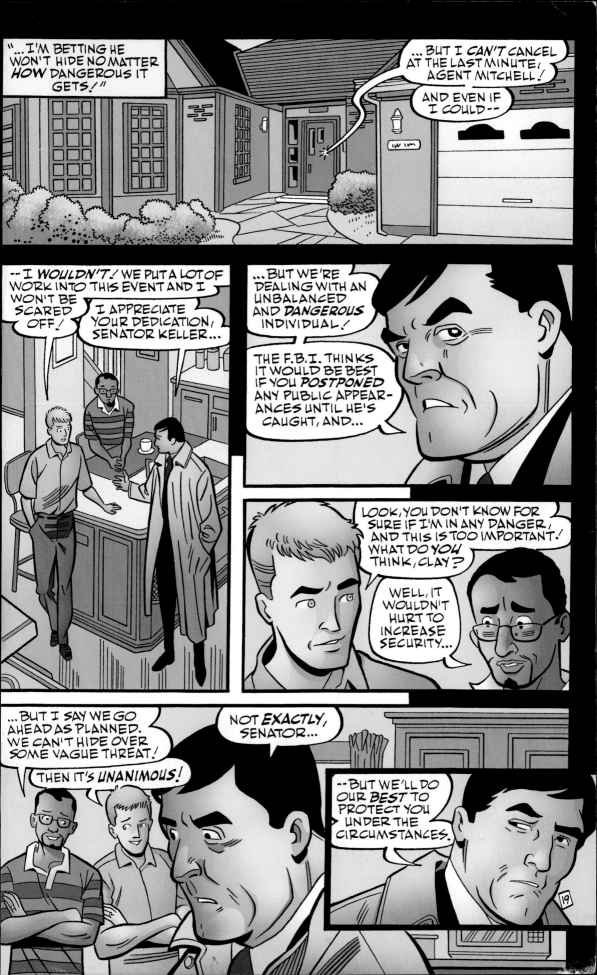

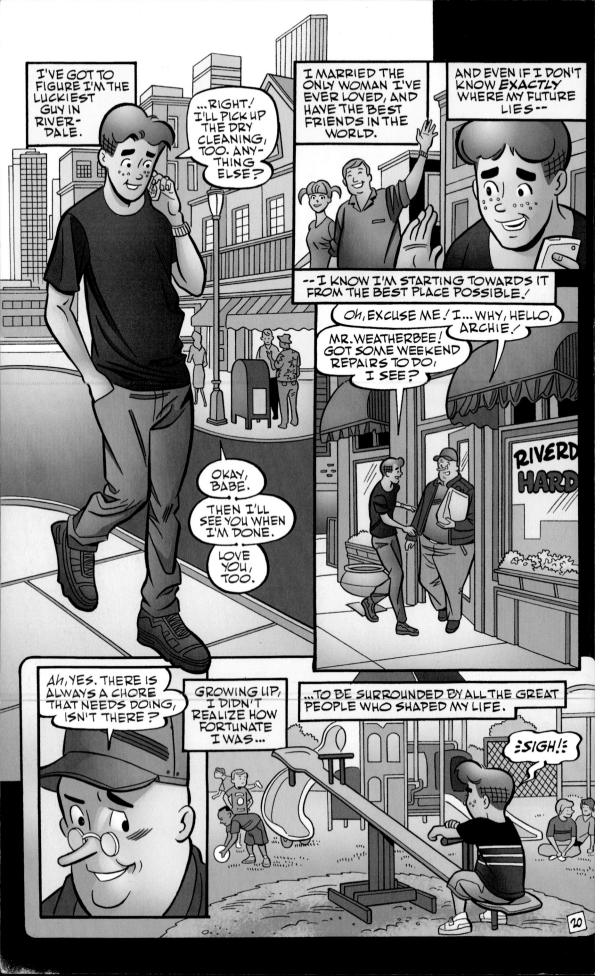

I'VE GOT TO FIGURE I'M THE LUCKIEST GUY IN RIVERDALE.

...RIGHT! I'LL PICK UP THE DRY CLEANING, TOO. ANYTHING ELSE?

I MARRIED THE ONLY WOMAN I'VE EVER LOVED, AND HAVE THE BEST FRIENDS IN THE WORLD.

AND EVEN IF I DON'T KNOW EXACTLY WHERE MY FUTURE LIES--

--I KNOW I'M STARTING TOWARDS IT FROM THE BEST PLACE POSSIBLE!

OH, EXCUSE ME! I...WHY, HELLO, ARCHIE!

MR. WEATHERBEE! GOT SOME WEEKEND REPAIRS TO DO, I SEE?

OKAY, BABE.

THEN I'LL SEE YOU WHEN I'M DONE.

LOVE YOU, TOO.

RIVERD HARD

Ah, YES. THERE IS ALWAYS A CHORE THAT NEEDS DOING, ISN'T THERE?

GROWING UP, I DIDN'T REALIZE HOW FORTUNATE I WAS...

...TO BE SURROUNDED BY ALL THE GREAT PEOPLE WHO SHAPED MY LIFE.

SIGH!

20

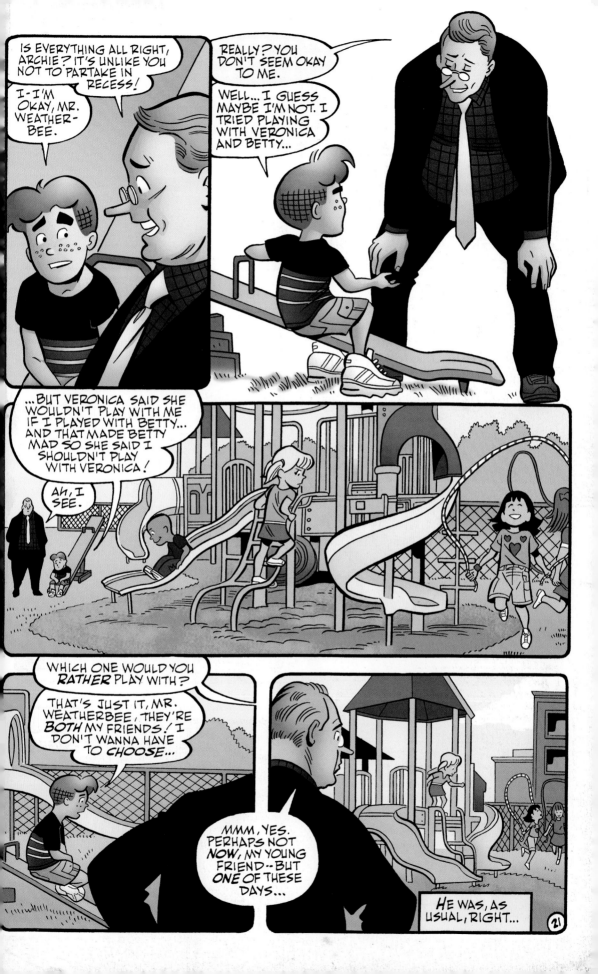

...SO WHAT IS IT ABOUT TODAY THAT'S BROUGHT MY MEMORY TO A BOIL AND GOT ME SO FIXATED ON THE PAST?

AT FIRST, I CHALK IT UP TO MR. PAVIA'S TALK ABOUT MY DAD, BUT THEN I REALIZE I WAS ALREADY WADING THROUGH MY LIFE *BEFORE* WE TALKED...

MAYBE IT'S JUST SOMETHING WE ALL GO THROUGH EVERY NOW AND THEN...

GLUE

47 00 KODAK 160VC 00

54 00 KODAK 160VC 00

23

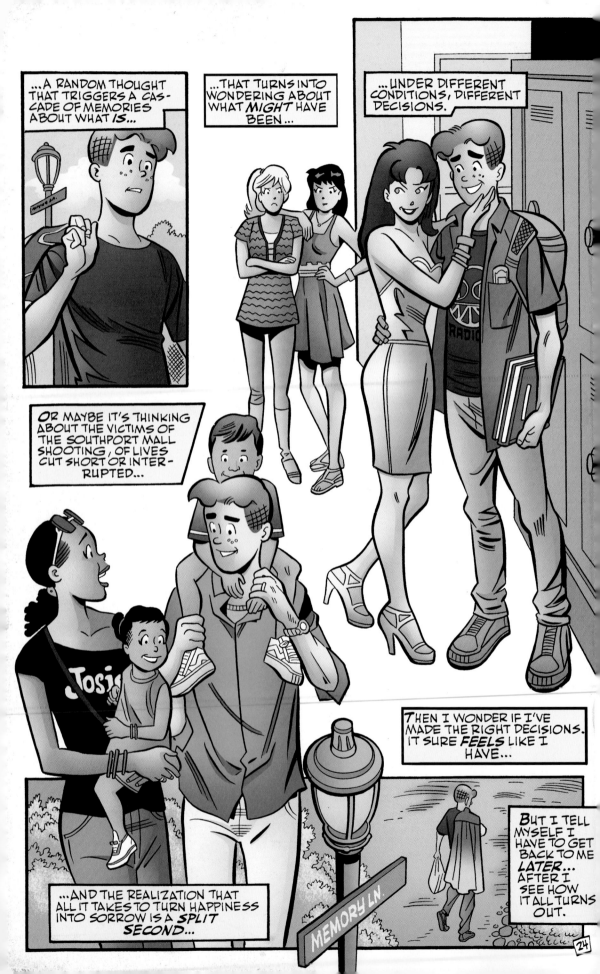

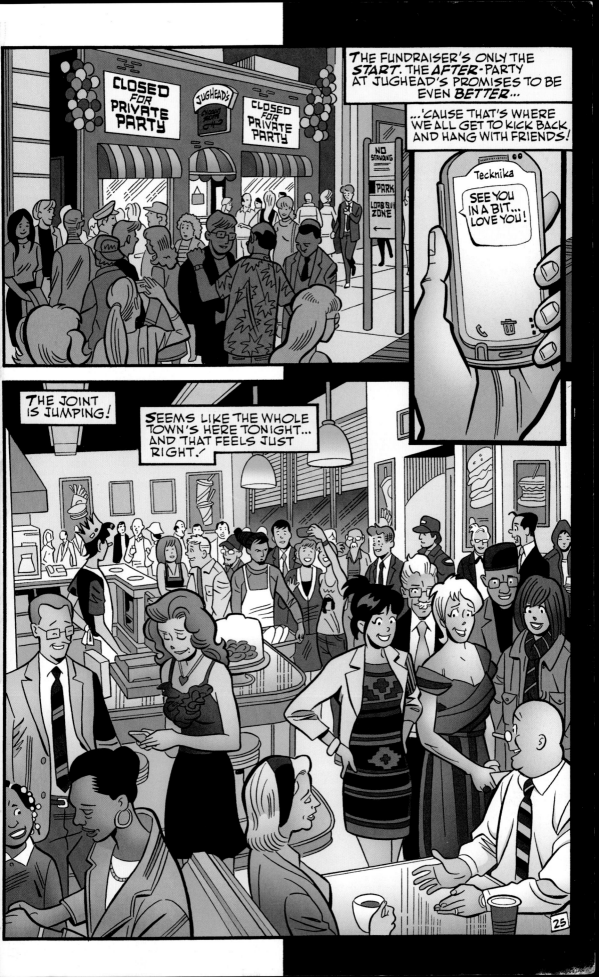

THE FUNDRAISER'S ONLY THE *START*. THE *AFTER*-PARTY AT JUGHEAD'S PROMISES TO BE EVEN *BETTER*...

...'CAUSE THAT'S WHERE WE ALL GET TO KICK BACK AND HANG WITH FRIENDS!

CLOSED FOR PRIVATE PARTY

JUGHEAD'S

CLOSED FOR PRIVATE PARTY

NO STANDING

PARK

LOADING ZONE

Tecknika

SEE YOU IN A BIT... LOVE YOU!

THE JOINT IS JUMPING!

SEEMS LIKE THE WHOLE TOWN'S HERE TONIGHT... AND THAT FEELS JUST *RIGHT*.

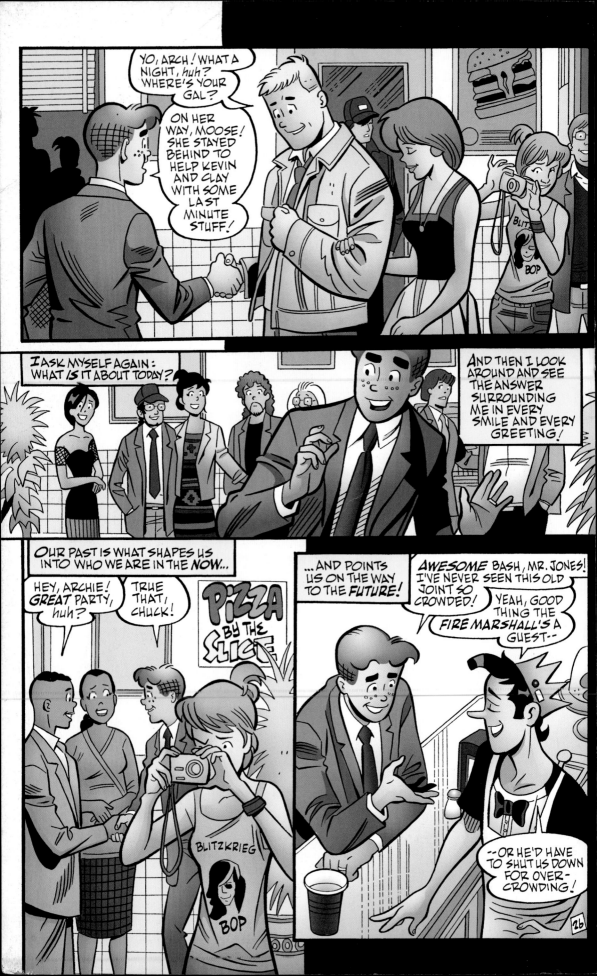

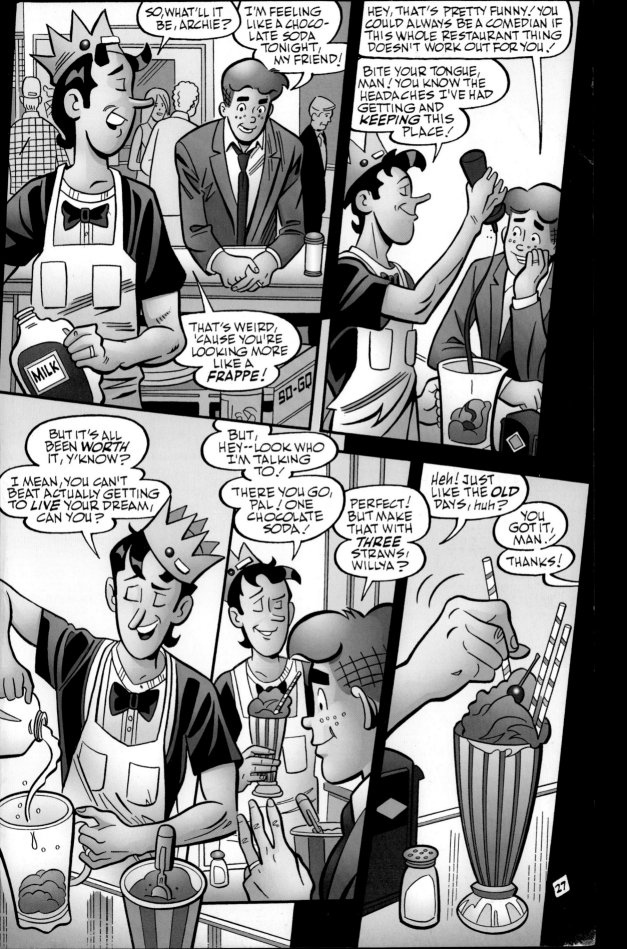

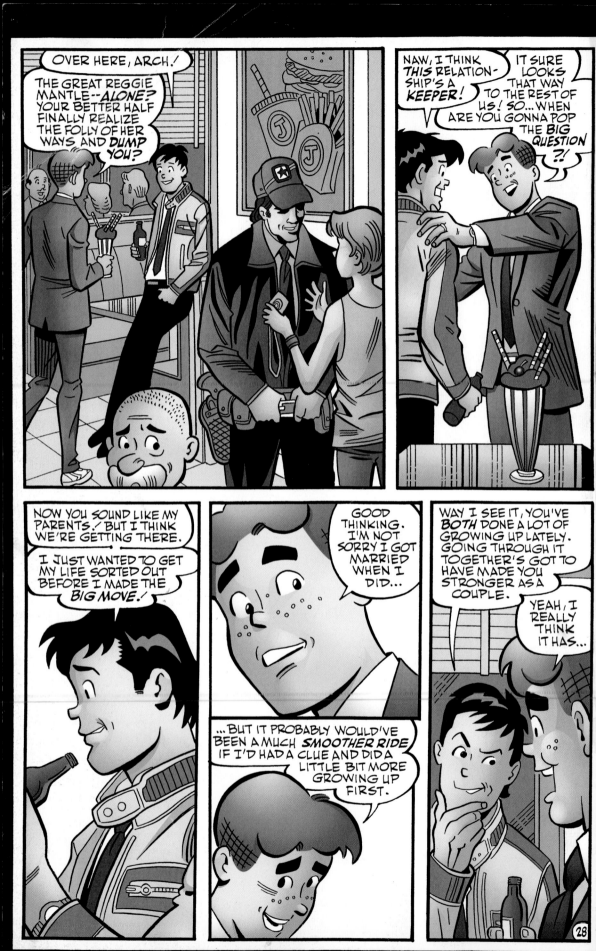

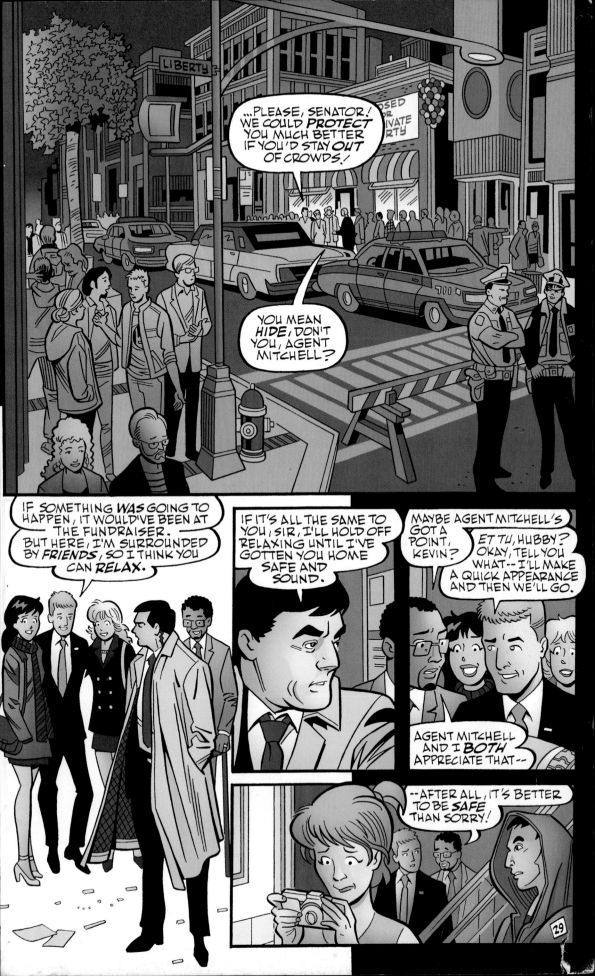

...PLEASE, SENATOR! WE COULD *PROTECT* YOU MUCH BETTER IF YOU'D STAY *OUT* OF CROWDS!

YOU MEAN *HIDE*, DON'T YOU, AGENT MITCHELL?

IF SOMETHING *WAS* GOING TO HAPPEN, IT WOULD'VE BEEN AT THE FUNDRAISER. BUT HERE, I'M SURROUNDED BY *FRIENDS*, SO I THINK YOU CAN *RELAX.*

IF IT'S ALL THE SAME TO YOU, SIR, I'LL HOLD OFF RELAXING UNTIL I'VE GOTTEN YOU HOME SAFE AND SOUND.

MAYBE AGENT MITCHELL'S GOT A POINT, KEVIN?

ET TU, HUBBY? OKAY, TELL YOU WHAT-- I'LL MAKE A QUICK APPEARANCE AND THEN WE'LL GO.

AGENT MITCHELL AND I *BOTH* APPRECIATE THAT--

--AFTER ALL, IT'S BETTER TO BE *SAFE* THAN SORRY!

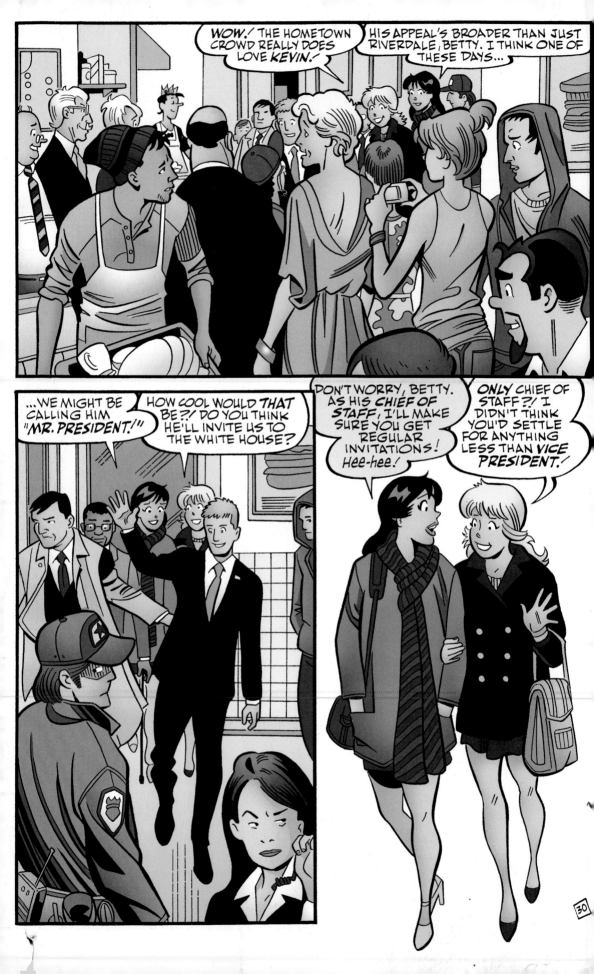

WOW! THE HOMETOWN CROWD REALLY DOES LOVE KEVIN!

HIS APPEAL'S BROADER THAN JUST RIVERDALE, BETTY. I THINK ONE OF THESE DAYS...

...WE MIGHT BE CALLING HIM "MR. PRESIDENT!"

HOW COOL WOULD THAT BE?! DO YOU THINK HE'LL INVITE US TO THE WHITE HOUSE?

DON'T WORRY, BETTY. AS HIS CHIEF OF STAFF, I'LL MAKE SURE YOU GET REGULAR INVITATIONS! Hee-hee!

ONLY CHIEF OF STAFF?! I DIDN'T THINK YOU'D SETTLE FOR ANYTHING LESS THAN VICE PRESIDENT!

30

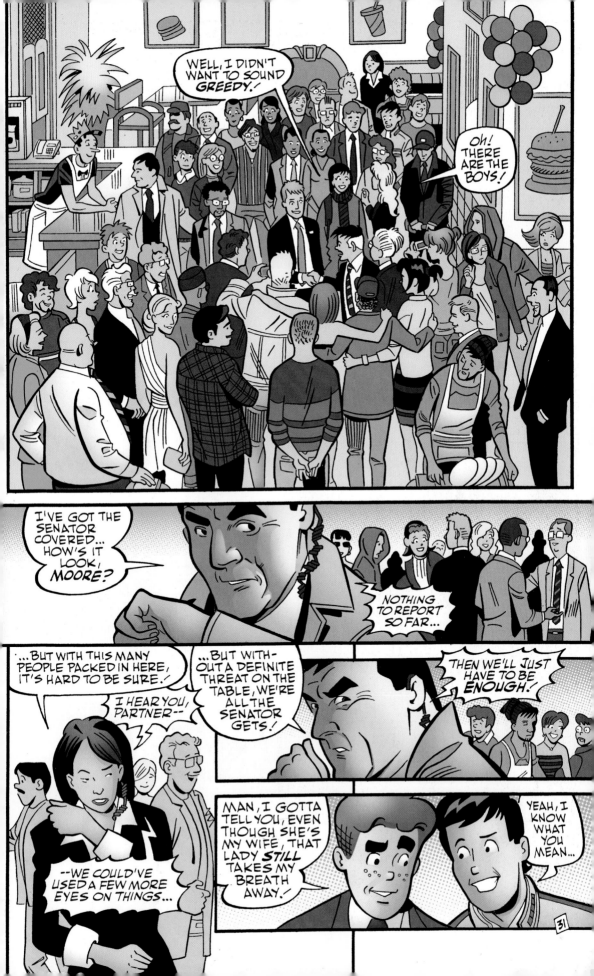

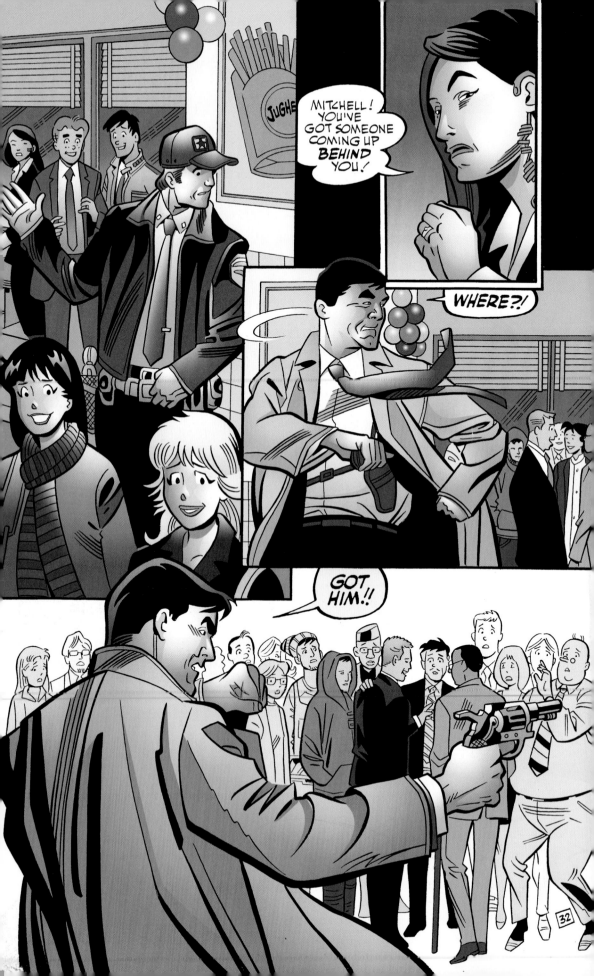

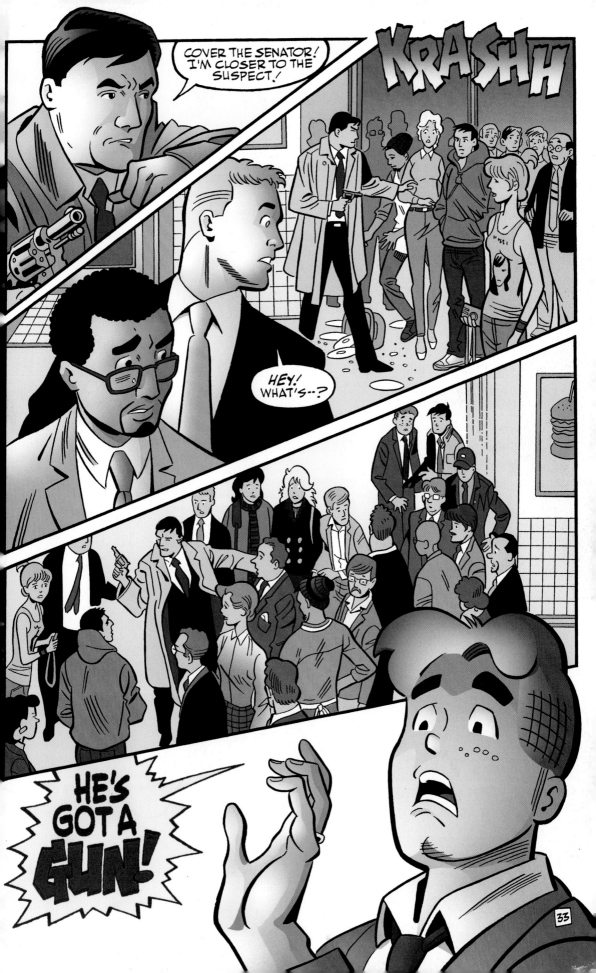

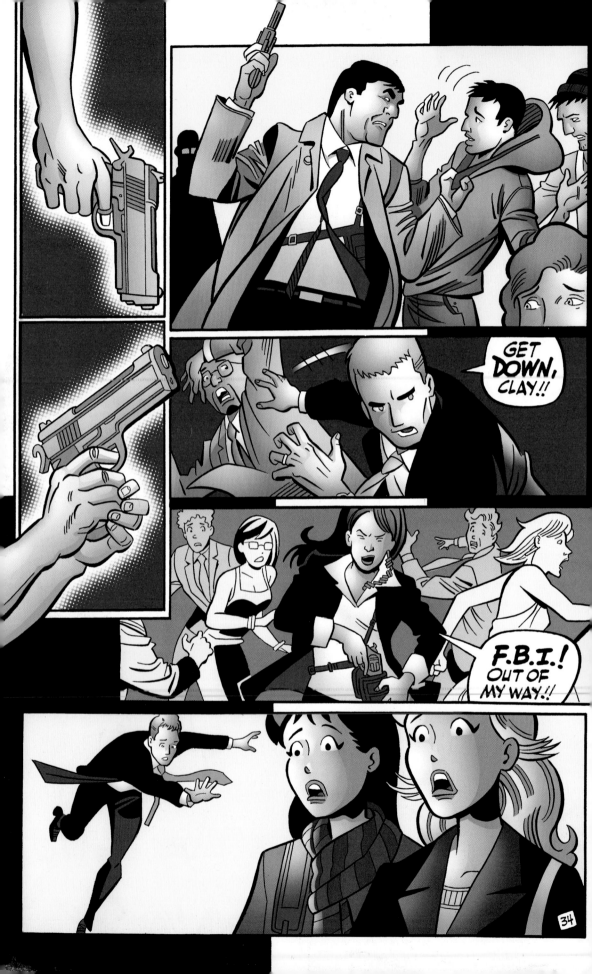

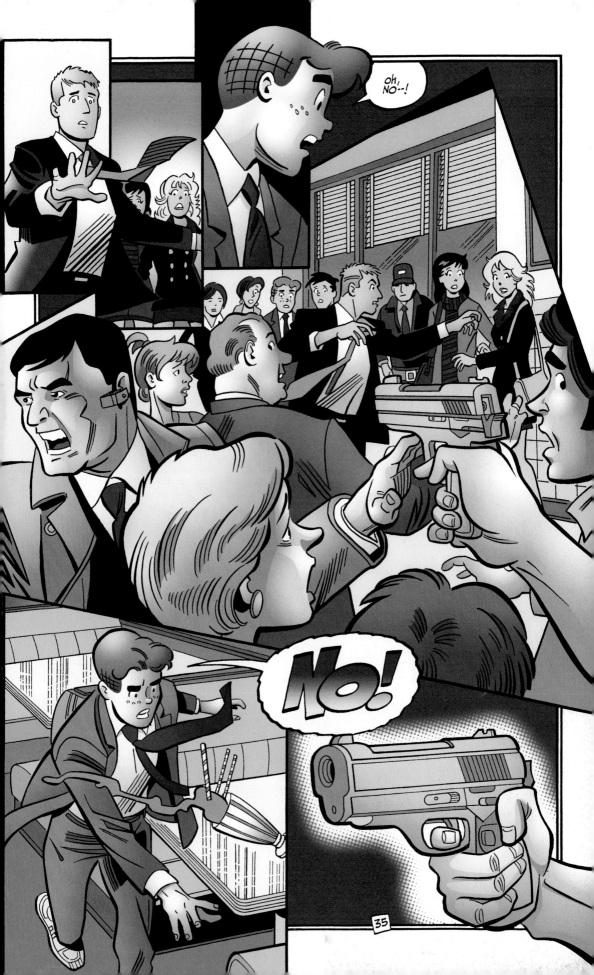

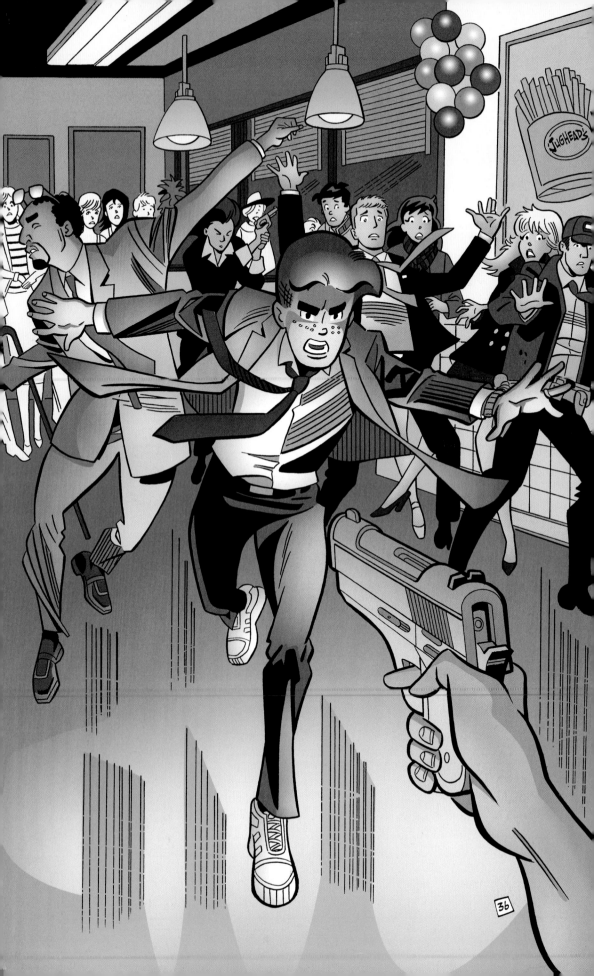

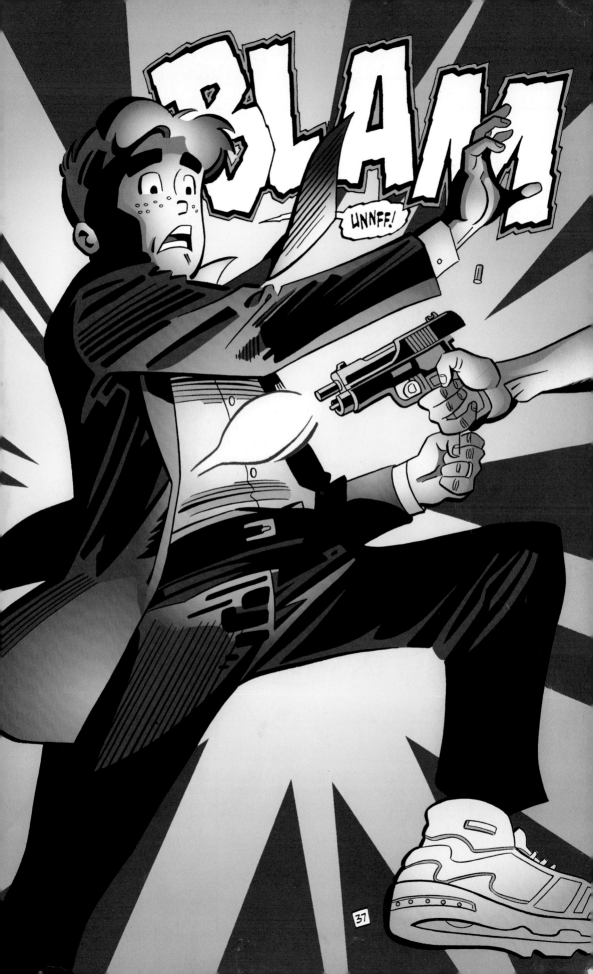

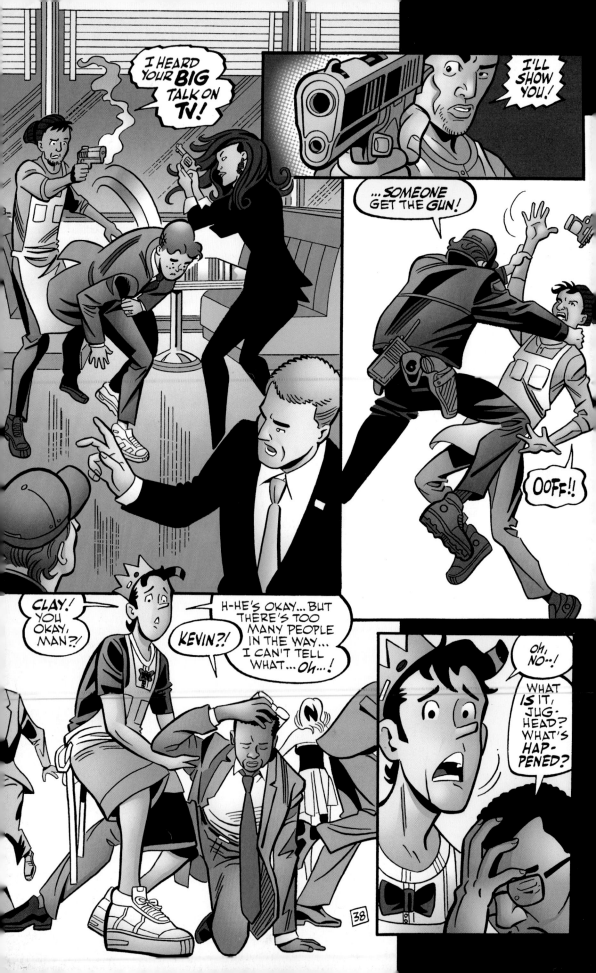

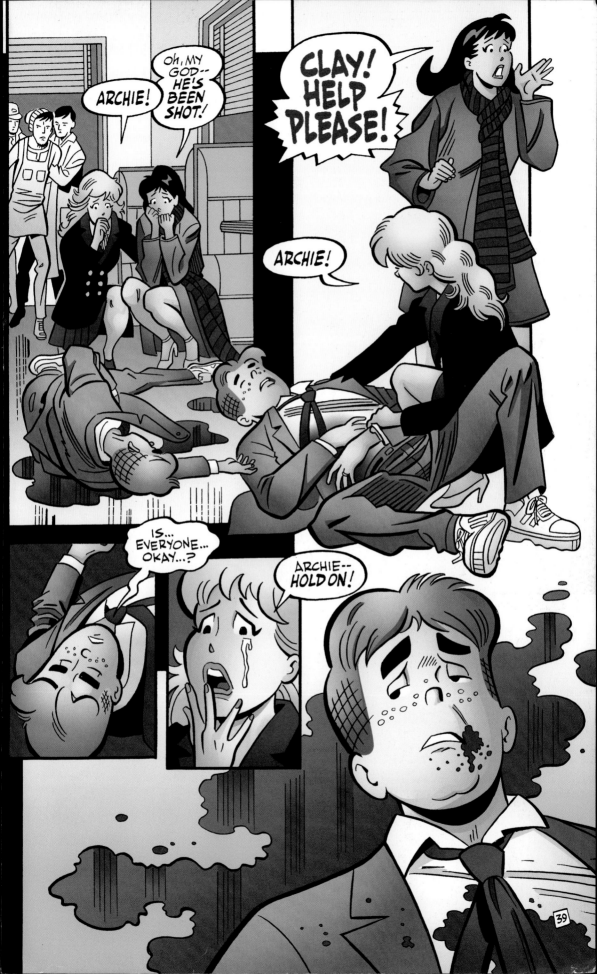

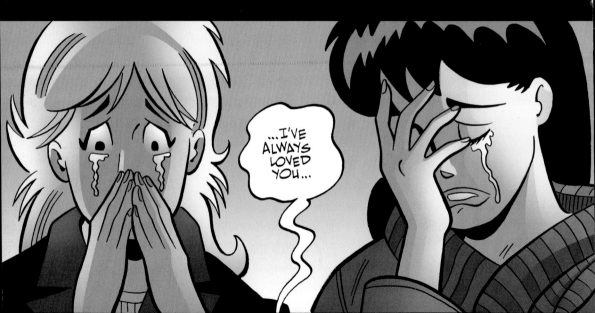

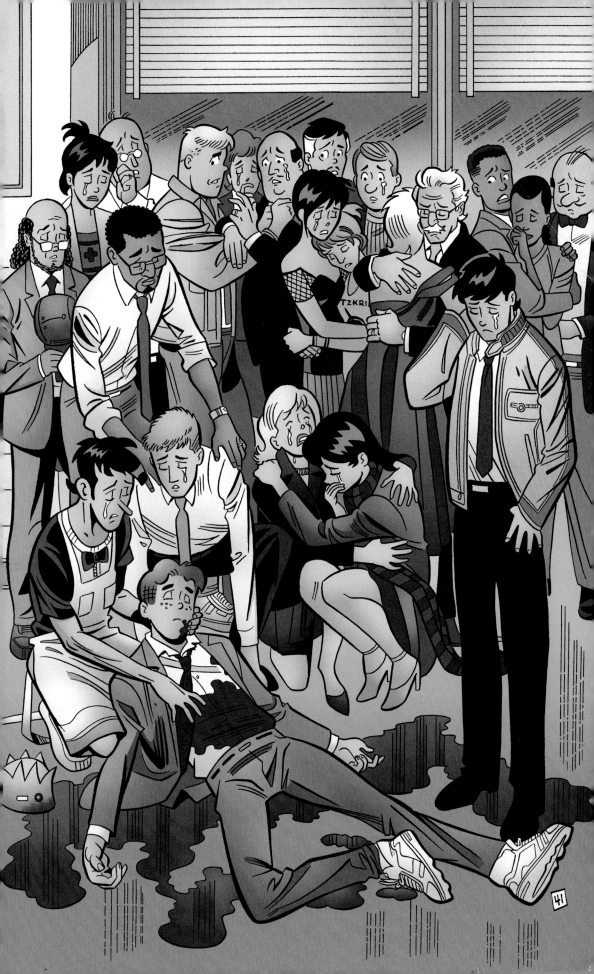

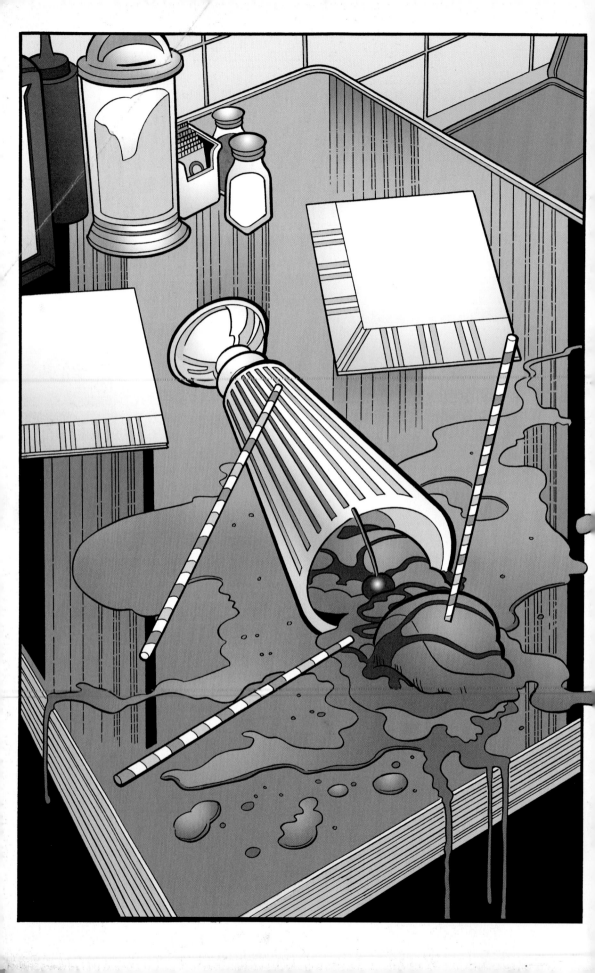

"OUR PAST IS WHAT SHAPES US INTO WHO WE ARE IN THE *NOW*..."

"...AND POINTS US ON THE WAY TO THE *FUTURE*."

- ARCHIE ANDREWS

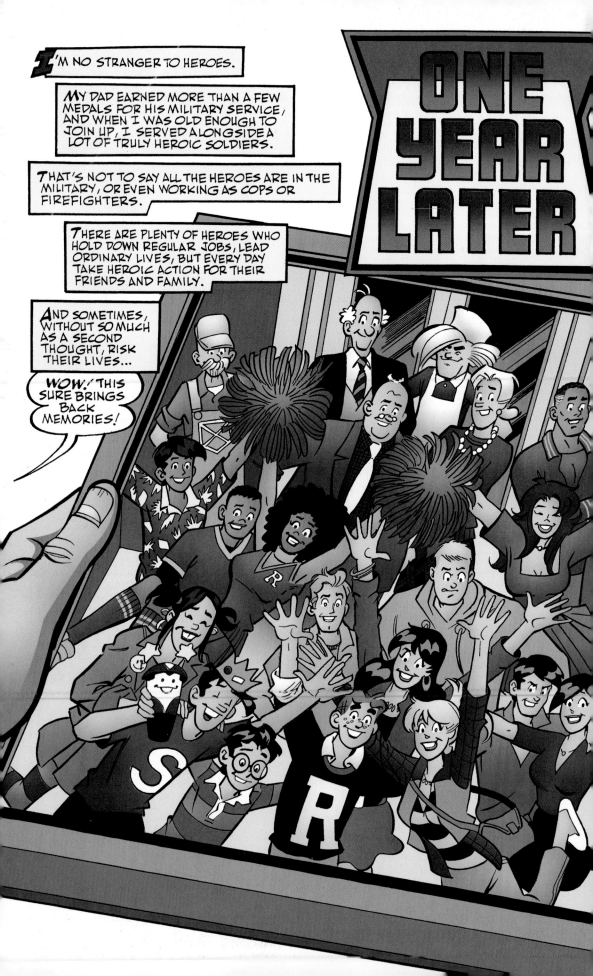

I'M NO STRANGER TO HEROES.

MY DAD EARNED MORE THAN A FEW MEDALS FOR HIS MILITARY SERVICE, AND WHEN I WAS OLD ENOUGH TO JOIN UP, I SERVED ALONGSIDE A LOT OF TRULY HEROIC SOLDIERS.

THAT'S NOT TO SAY ALL THE HEROES ARE IN THE MILITARY, OR EVEN WORKING AS COPS OR FIREFIGHTERS.

THERE ARE PLENTY OF HEROES WHO HOLD DOWN REGULAR JOBS, LEAD ORDINARY LIVES, BUT EVERY DAY TAKE HEROIC ACTION FOR THEIR FRIENDS AND FAMILY.

AND SOMETIMES, WITHOUT SO MUCH AS A SECOND THOUGHT, RISK THEIR LIVES...

WOW! THIS SURE BRINGS BACK MEMORIES!

ONE YEAR LATER

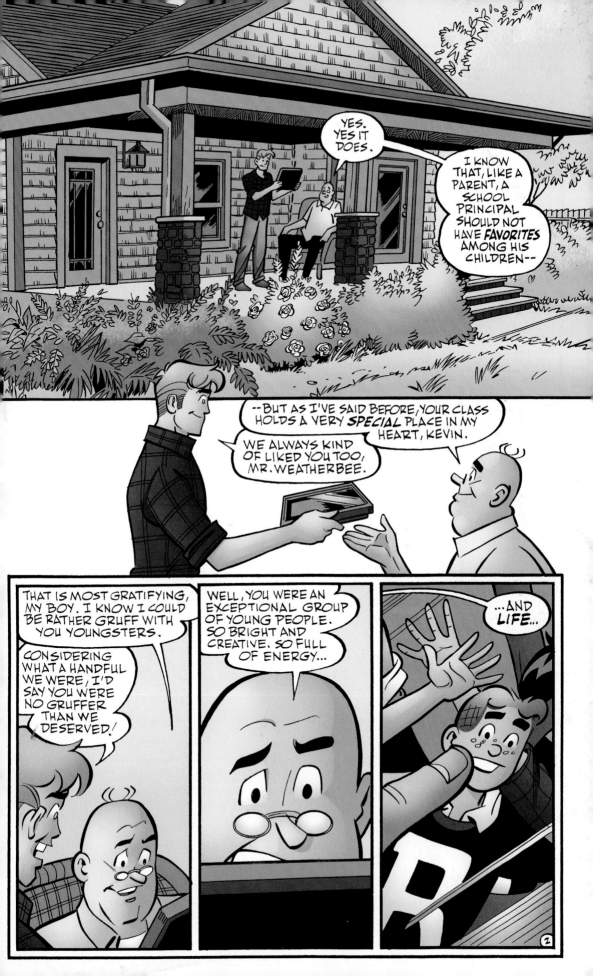

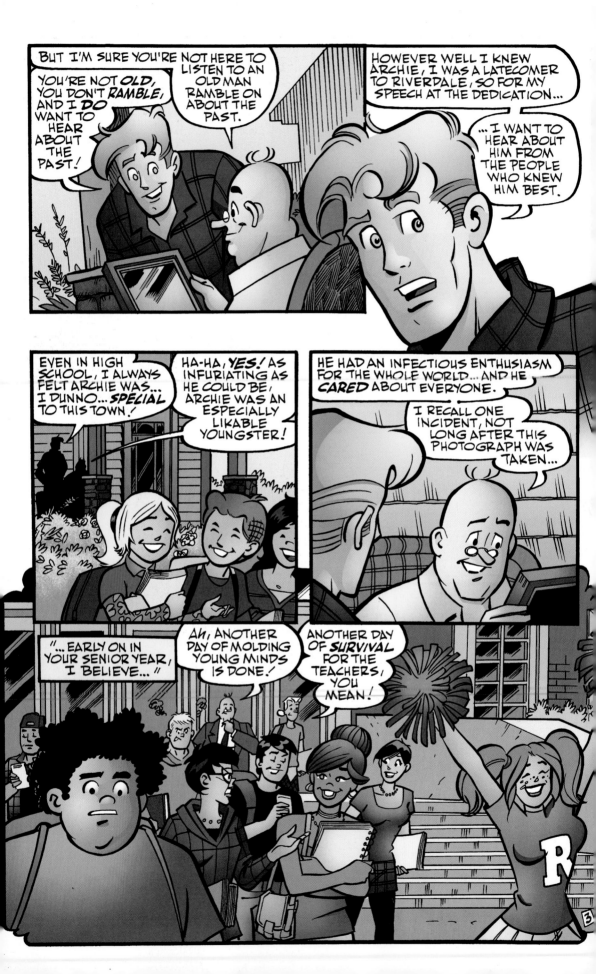

BUT I'M SURE YOU'RE NOT HERE TO LISTEN TO AN OLD MAN RAMBLE ON ABOUT THE PAST.

YOU'RE NOT *OLD*, YOU DON'T *RAMBLE*, AND I *DO* WANT TO HEAR ABOUT THE PAST!

HOWEVER WELL I KNEW ARCHIE, I WAS A LATECOMER TO RIVERDALE, SO FOR MY SPEECH AT THE DEDICATION...

...I WANT TO HEAR ABOUT HIM FROM THE PEOPLE WHO KNEW HIM BEST.

EVEN IN HIGH SCHOOL, I ALWAYS FELT ARCHIE WAS... I DUNNO... *SPECIAL* TO THIS TOWN!

HA-HA, *YES!* AS INFURIATING AS HE COULD BE, ARCHIE WAS AN ESPECIALLY LIKABLE YOUNGSTER!

HE HAD AN INFECTIOUS ENTHUSIASM FOR THE WHOLE WORLD... AND HE *CARED* ABOUT EVERYONE.

I RECALL ONE INCIDENT, NOT LONG AFTER THIS PHOTOGRAPH WAS TAKEN...

"...EARLY ON IN YOUR SENIOR YEAR, I BELIEVE..."

AH, ANOTHER DAY OF MOLDING YOUNG MINDS IS DONE!

ANOTHER DAY OF *SURVIVAL* FOR THE TEACHERS, YOU MEAN!

3

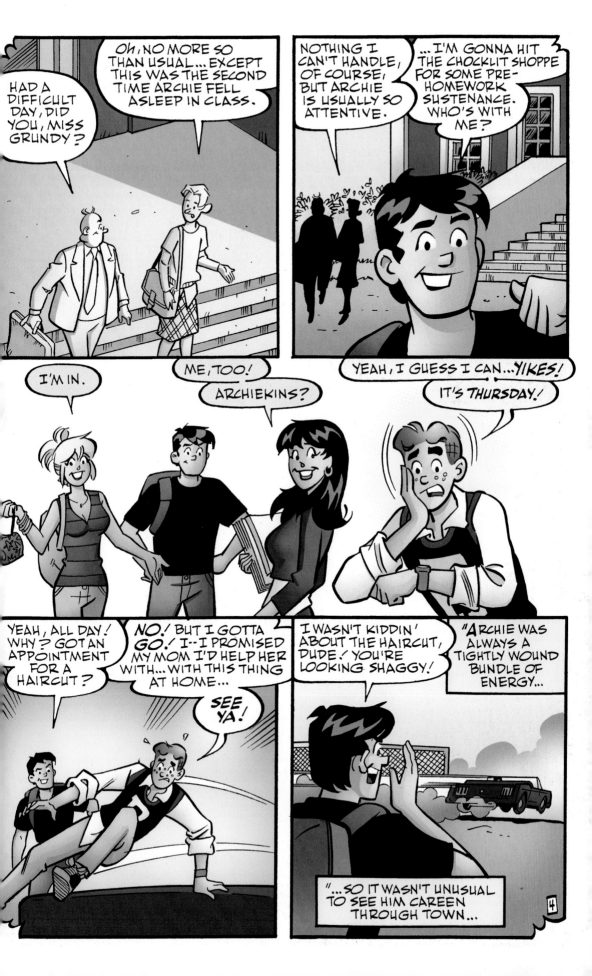

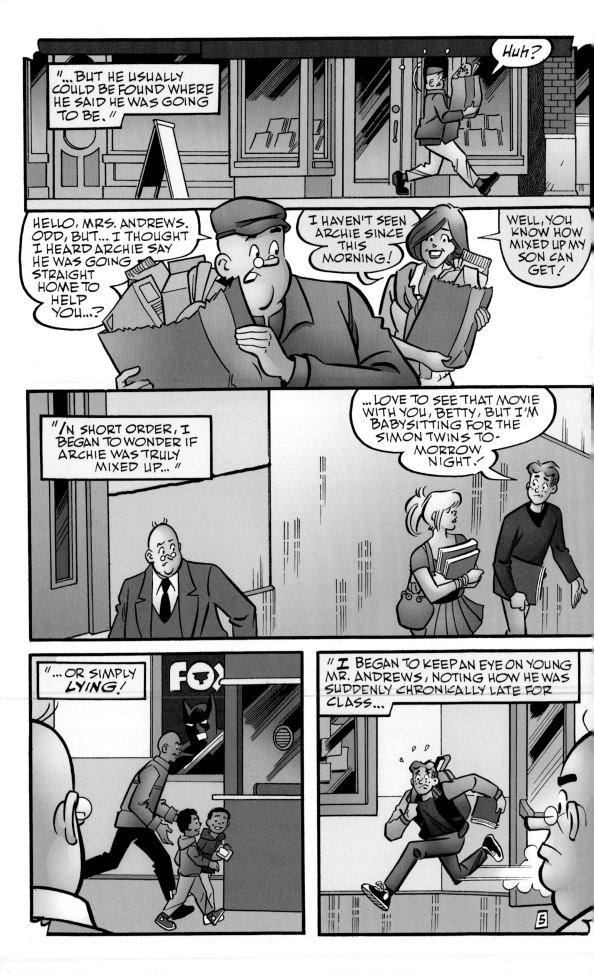

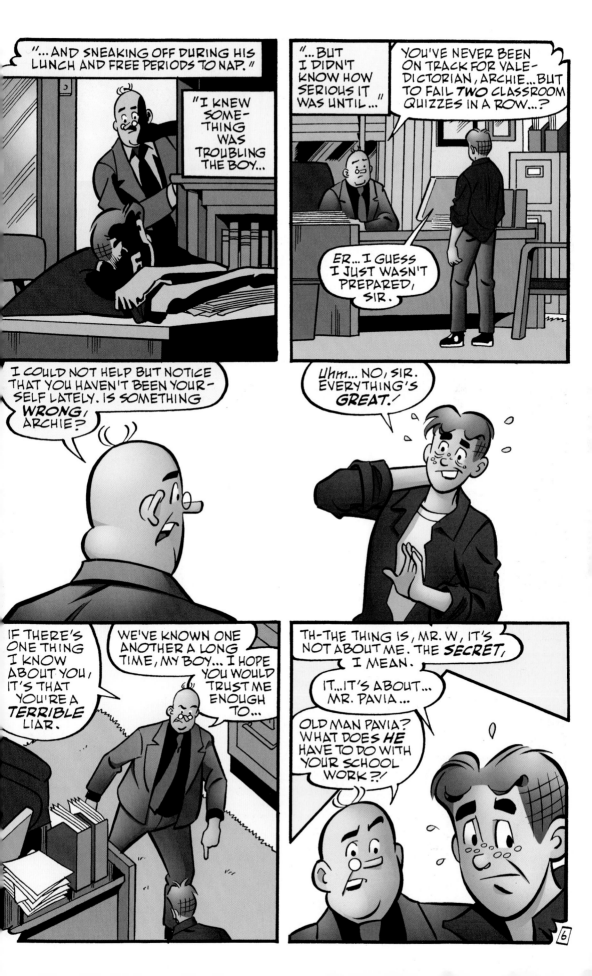

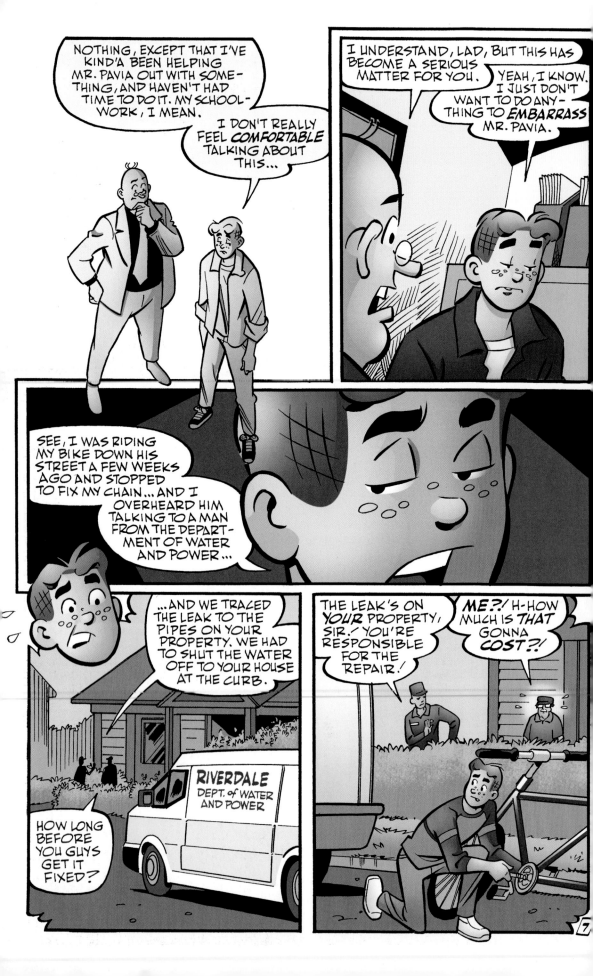

NOTHING, EXCEPT THAT I'VE KIND'A BEEN HELPING MR. PAVIA OUT WITH SOMETHING, AND HAVEN'T HAD TIME TO DO IT. MY SCHOOLWORK, I MEAN.

I DON'T REALLY FEEL *COMFORTABLE* TALKING ABOUT THIS...

I UNDERSTAND, LAD, BUT THIS HAS BECOME A SERIOUS MATTER FOR YOU.

YEAH, I KNOW. I JUST DON'T WANT TO DO ANYTHING TO *EMBARRASS* MR. PAVIA.

SEE, I WAS RIDING MY BIKE DOWN HIS STREET A FEW WEEKS AGO AND STOPPED TO FIX MY CHAIN... AND I OVERHEARD HIM TALKING TO A MAN FROM THE DEPARTMENT OF WATER AND POWER...

...AND WE TRACED THE LEAK TO THE PIPES ON YOUR PROPERTY. WE HAD TO SHUT THE WATER OFF TO YOUR HOUSE AT THE CURB.

RIVERDALE DEPT. of WATER AND POWER

HOW LONG BEFORE YOU GUYS GET IT FIXED?

THE LEAK'S ON *YOUR* PROPERTY, SIR! YOU'RE RESPONSIBLE FOR THE REPAIR!

ME?! H-HOW MUCH IS *THAT* GONNA *COST?!*

7

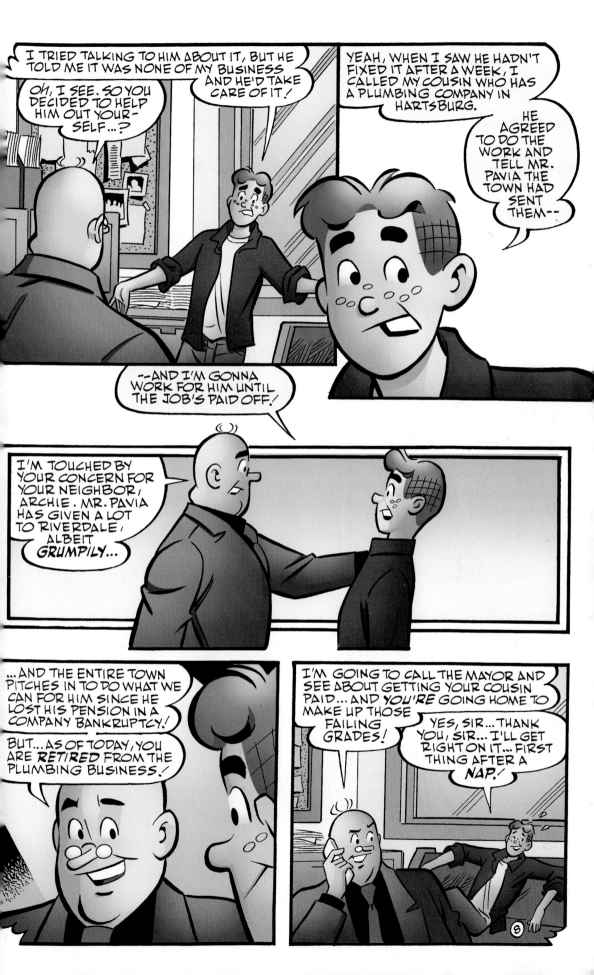

MY OFFICE GETS ALL SORTS OF STATISTICS ABOUT THINGS YOU CAN'T EVEN IMAGINE, AND RIVERDALE RANKED *FIRST* IN AT LEAST ONE CATEGORY

IN PERCENTAGE OF RESIDENTS BORN HERE WHO NEVER LEAVE.

FOR NATIVES, RIVERDALE ISN'T JUST A NICE PLACE TO LIVE. IT'S THE *ONLY* PLACE.

...WHAT DO *I* REMEMBER ABOUT ARCHIE?

SENATOR, I'M PRACTICALLY *OVERWHELMED* WITH MEMORIES OF THAT BOY!

WELL, OUR HOUSE WAS A VIRTUAL SECOND HOME TO ALL YOU KIDS... EVEN BEFORE YOU MOVED TO TOWN, KEVIN!

I'M REALLY LOOKING FOR STORIES THAT SHOW WHAT TIED ARCHIE SO CLOSELY TO RIVERDALE.

THEN I WOULD SAY YOU COULDN'T FIND A BETTER STORY THAN THE ONE OF *PICKENS PARK.*

OH, MY, YES! WITHOUT ARCHIE, THE ENTIRE PARK MIGHT VERY WELL HAVE BEEN REPLACED BY A *SHOPPING PLAZA!*

I THOUGHT *YOU* SAVED THE PARK FROM DEMOLITION, MR. LODGE?

I JUST GAVE A LOT OF MONEY AND HELPED RAISE A LOT MORE.

PICKENS PARK

9

BUT THE REAL CREDIT FOR SAVING THIS PARK HAS TO GO TO ARCHIE, WHICH I SUPPOSE IS FITTING... AS IT WAS AN *ANDREWS* IN THE 19TH CENTURY WHO DONATED THE LAND TO THE TOWN FOR A PARK.

PICKENS PARK

THERE ARE THOSE WHO BELIEVE IT WAS AN ANDREWS WHO FIRST SETTLED IN RIVERDALE...

NOT *ME*, OF COURSE... I SAY IT WAS A *LODGE*, NO DOUBT! EITHER WAY, ARCHIE'S IS A DISTINGUISHED ANCESTRY--

"--AND HE SEEMED DESTINED TO START FOLLOWING IN HIS FAMILY FOOTSTEPS EARLY ON..."

THIS IS *PATHETIC!*

YEAH, SOMEBODY OUGHT TO *DO* SOMETHING ABOUT THIS!

MY DAD SAYS IT'S THE *TOWN'S* JOB, BUT BECAUSE OF THE ECONOMY, IT CAN'T AFFORD TO!

ISN'T THERE ANYTHING *WE* CAN DO?

LIKE WHAT? REPLANT STUFF? FIX BENCHES?

10

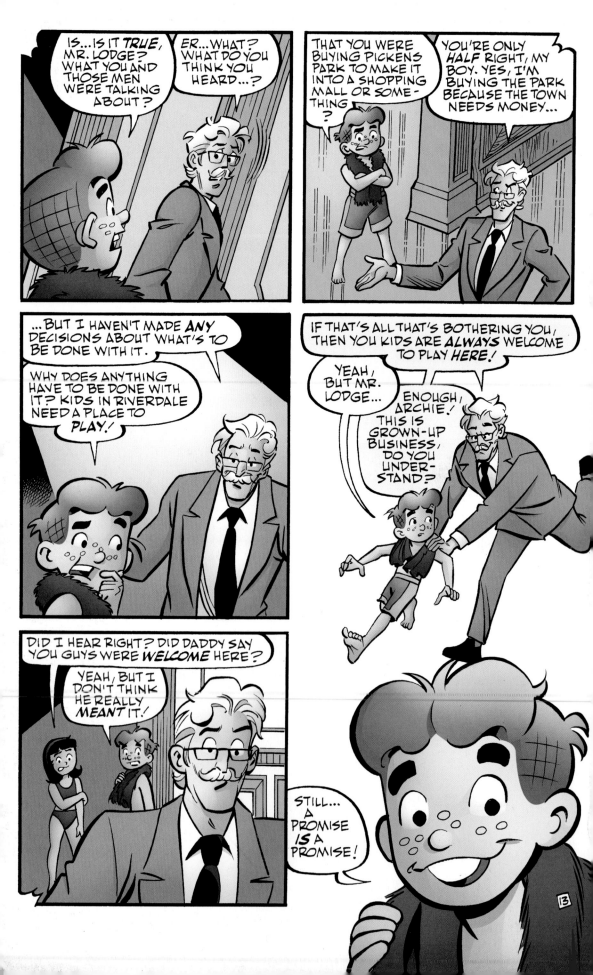

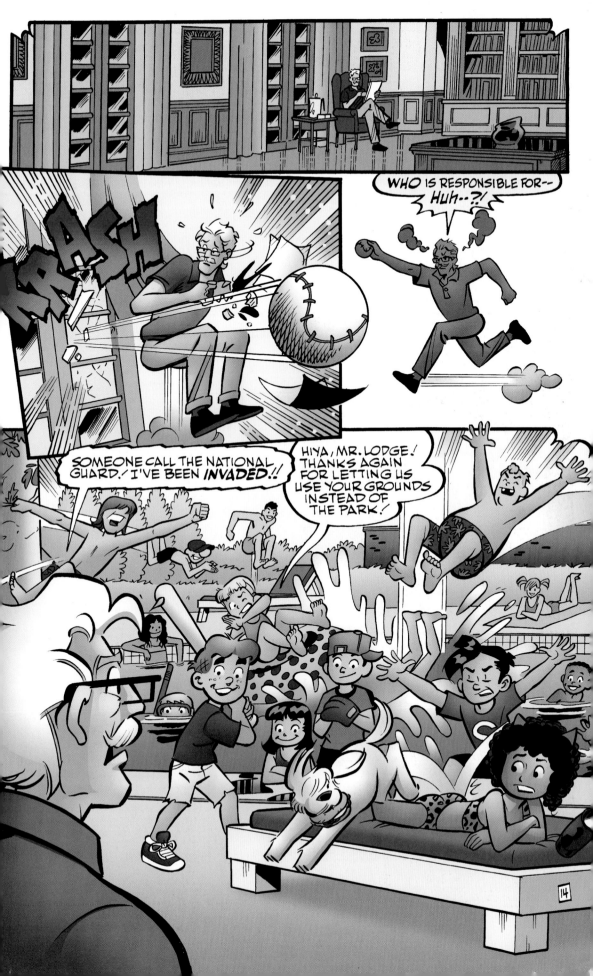

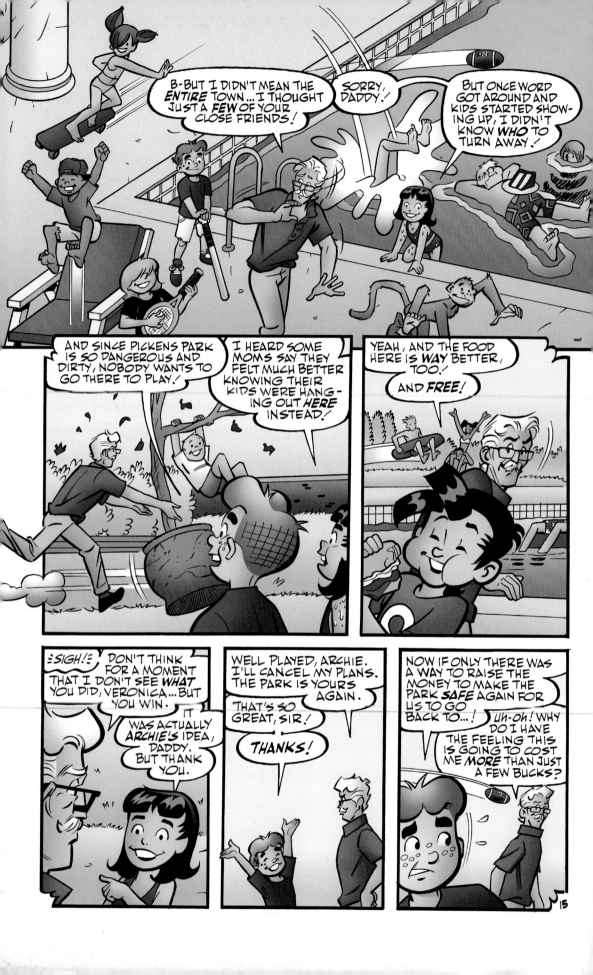

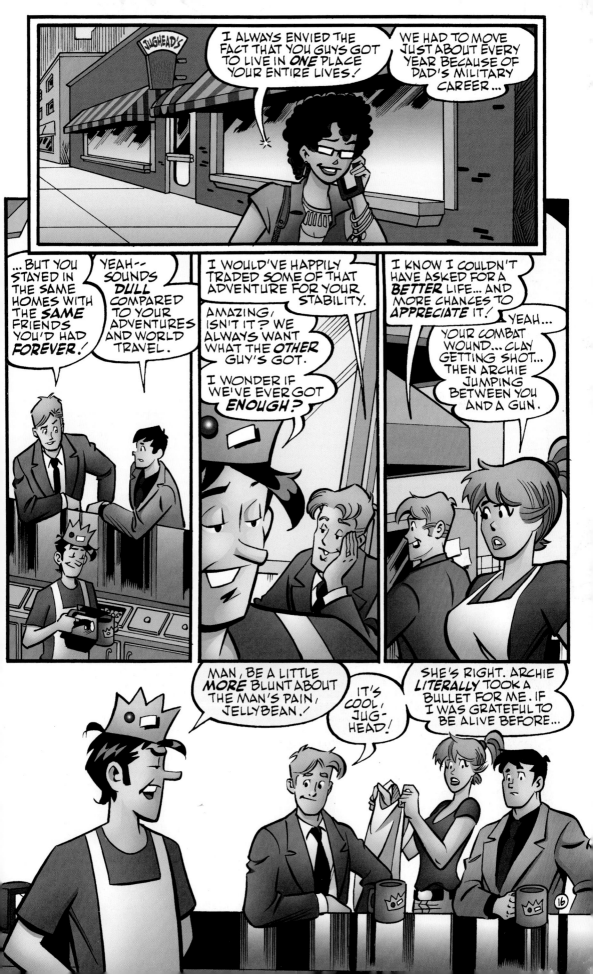

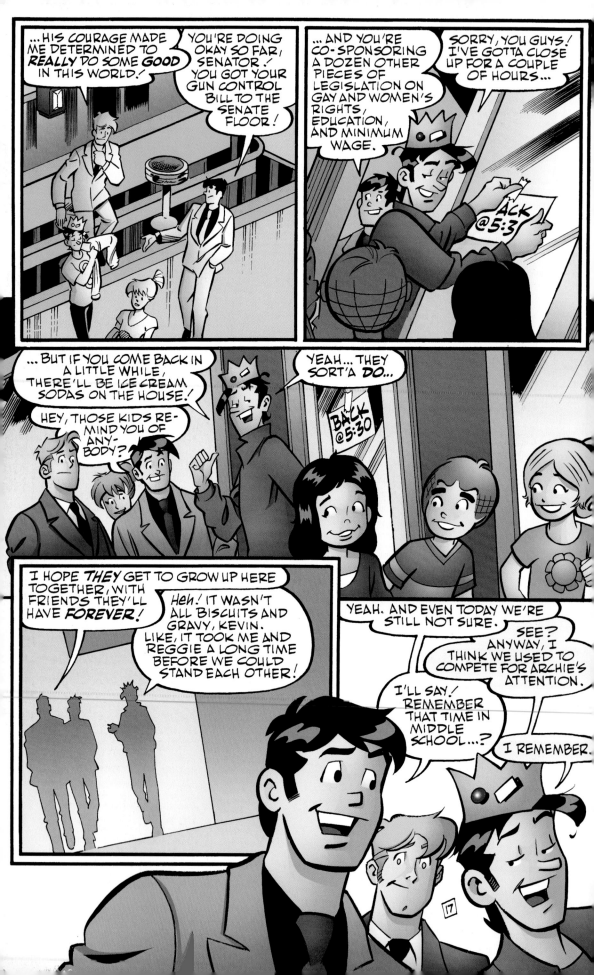

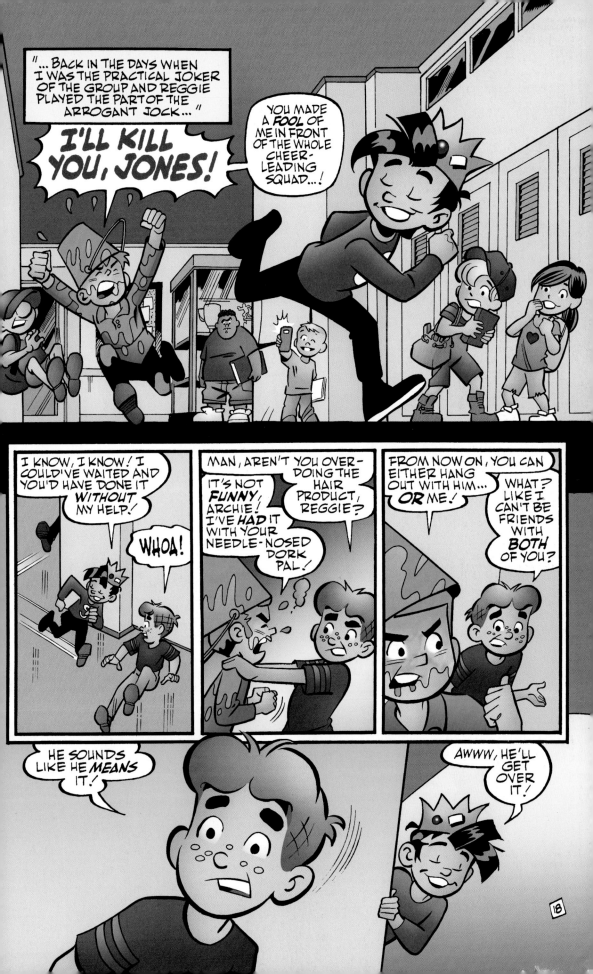

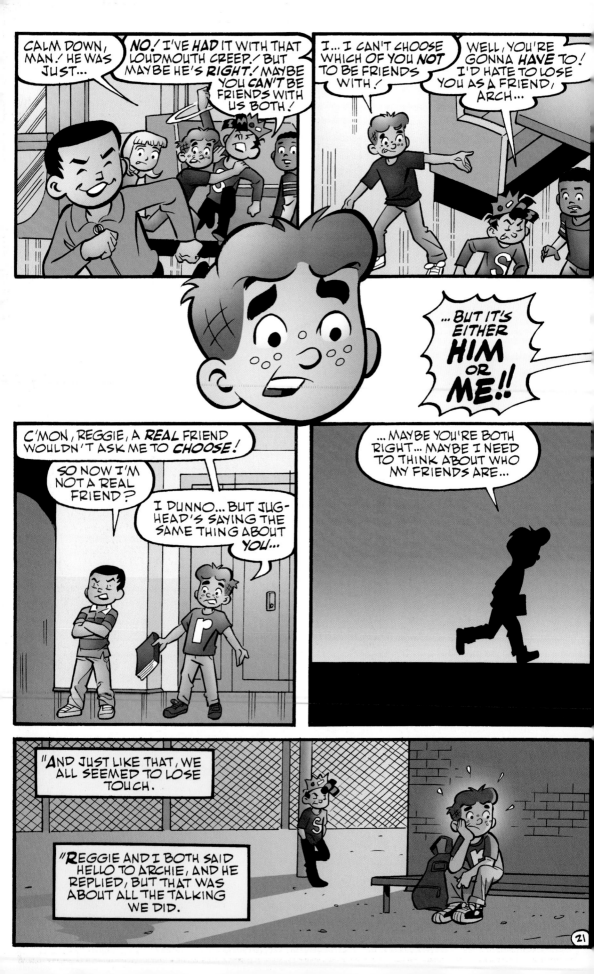

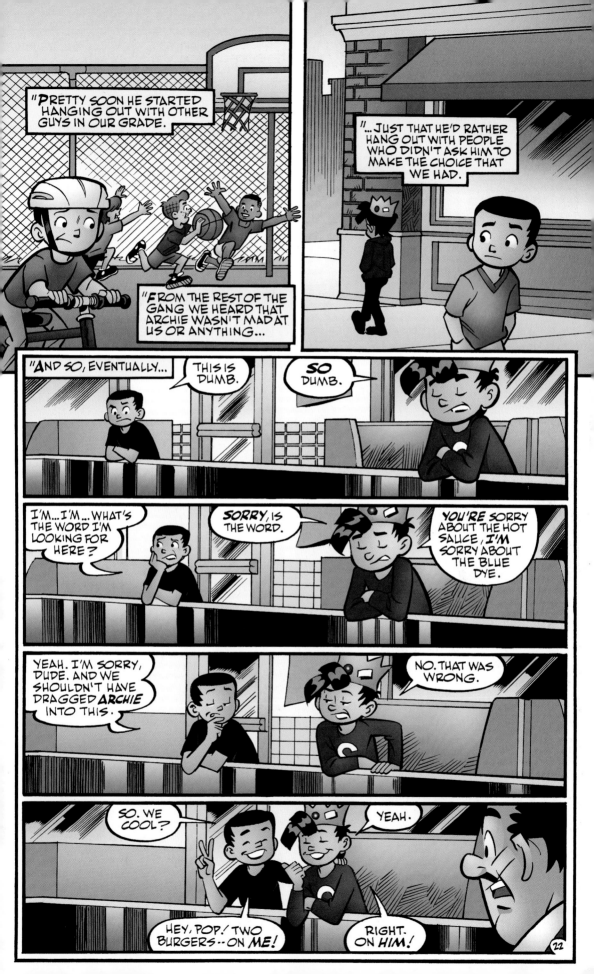

"PRETTY SOON HE STARTED HANGING OUT WITH OTHER GUYS IN OUR GRADE.

"...JUST THAT HE'D RATHER HANG OUT WITH PEOPLE WHO DIDN'T ASK HIM TO MAKE THE CHOICE THAT WE HAD.

"FROM THE REST OF THE GANG WE HEARD THAT ARCHIE WASN'T MAD AT US OR ANYTHING...

"AND SO, EVENTUALLY...

THIS IS DUMB.

SO DUMB.

I'M...I'M...WHAT'S THE WORD I'M LOOKING FOR HERE?

SORRY, IS THE WORD.

YOU'RE SORRY ABOUT THE HOT SAUCE, I'M SORRY ABOUT THE BLUE DYE.

YEAH. I'M SORRY, DUDE. AND WE SHOULDN'T HAVE DRAGGED ARCHIE INTO THIS.

NO. THAT WAS WRONG.

SO. WE COOL?

YEAH.

HEY, POP! TWO BURGERS--ON ME!

RIGHT. ON HIM!

22

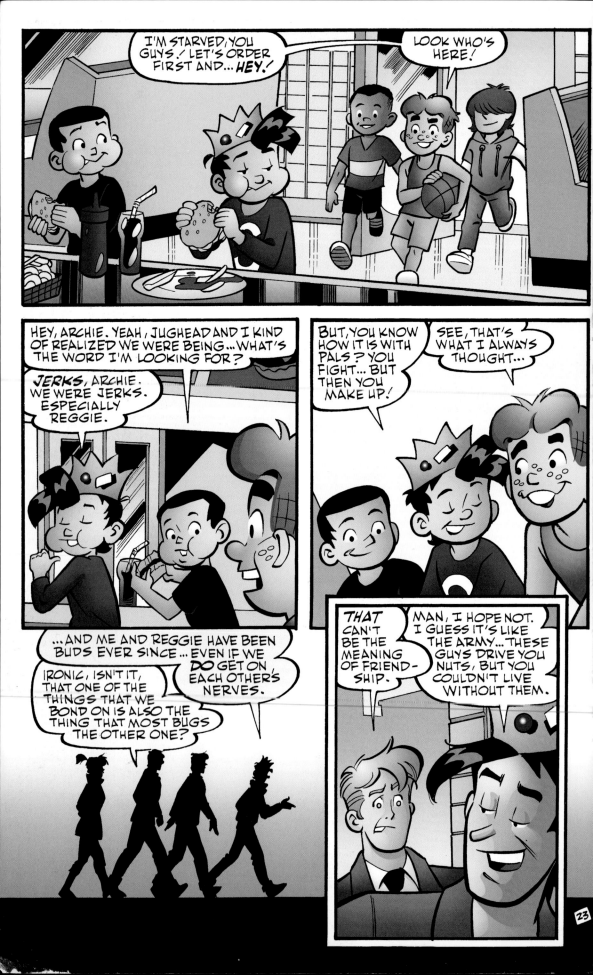

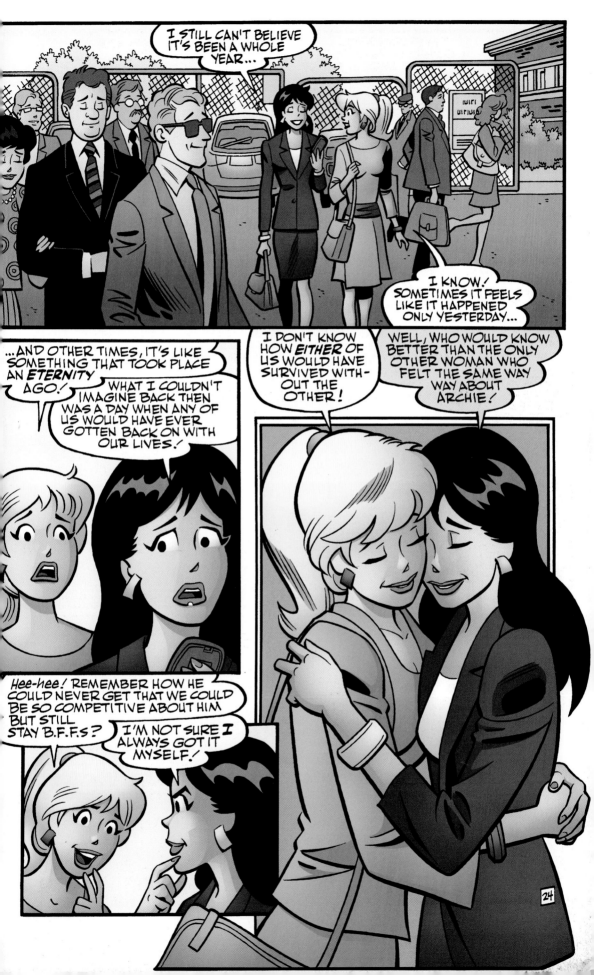

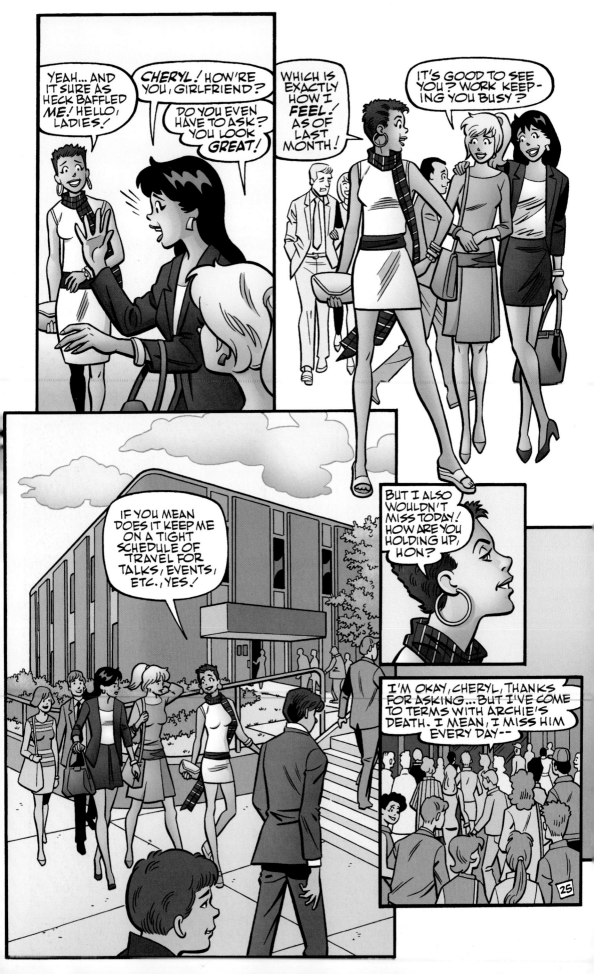

YEAH... AND IT SURE AS HECK BAFFLED *ME!* HELLO, LADIES!

CHERYL! HOW'RE YOU, GIRLFRIEND?

DO YOU EVEN HAVE TO ASK? YOU LOOK *GREAT!*

WHICH IS EXACTLY HOW I *FEEL!* AS OF LAST MONTH!

IT'S GOOD TO SEE YOU! WORK KEEPING YOU BUSY?

IF YOU MEAN DOES IT KEEP ME ON A TIGHT SCHEDULE OF TRAVEL FOR TALKS, EVENTS, ETC., YES!

BUT I ALSO WOULDN'T MISS TODAY! HOW ARE YOU HOLDING UP, HON?

I'M OKAY, CHERYL, THANKS FOR ASKING... BUT I'VE COME TO TERMS WITH ARCHIE'S DEATH. I MEAN, I MISS HIM EVERY DAY--

25

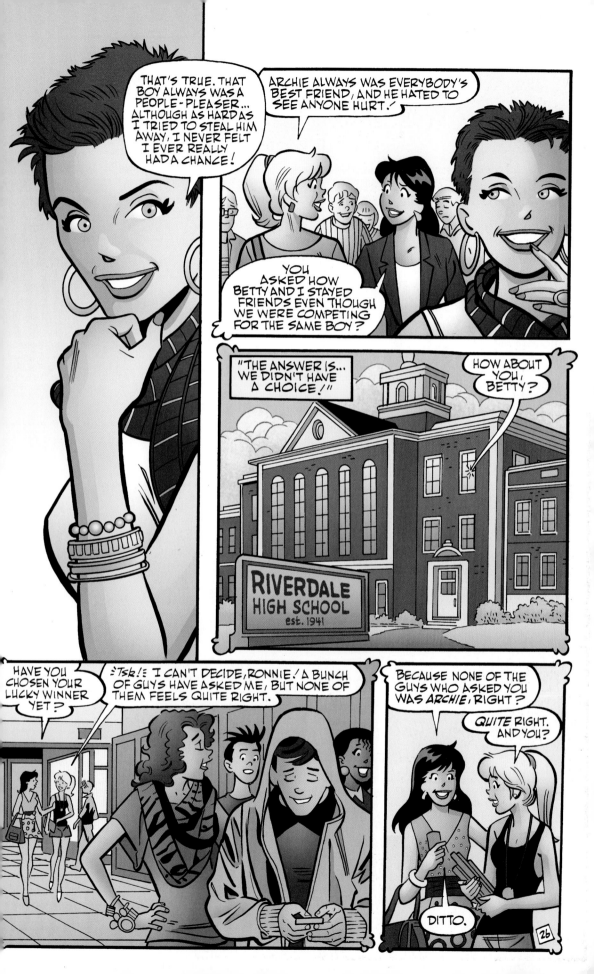

THAT'S TRUE. THAT BOY ALWAYS WAS A PEOPLE-PLEASER... ALTHOUGH AS HARD AS I TRIED TO STEAL HIM AWAY, I NEVER FELT I EVER REALLY HAD A CHANCE!

ARCHIE ALWAYS WAS EVERYBODY'S BEST FRIEND, AND HE HATED TO SEE ANYONE HURT.

YOU ASKED HOW BETTY AND I STAYED FRIENDS EVEN THOUGH WE WERE COMPETING FOR THE SAME BOY?

"THE ANSWER IS... WE DIDN'T HAVE A CHOICE!"

HOW ABOUT YOU, BETTY?

RIVERDALE HIGH SCHOOL
est. 1941

HAVE YOU CHOSEN YOUR LUCKY WINNER YET?

⸗Tsk!⸗ I CAN'T DECIDE, RONNIE! A BUNCH OF GUYS HAVE ASKED ME, BUT NONE OF THEM FEELS QUITE RIGHT.

BECAUSE NONE OF THE GUYS WHO ASKED YOU WAS ARCHIE, RIGHT?

QUITE RIGHT. AND YOU?

DITTO.

26

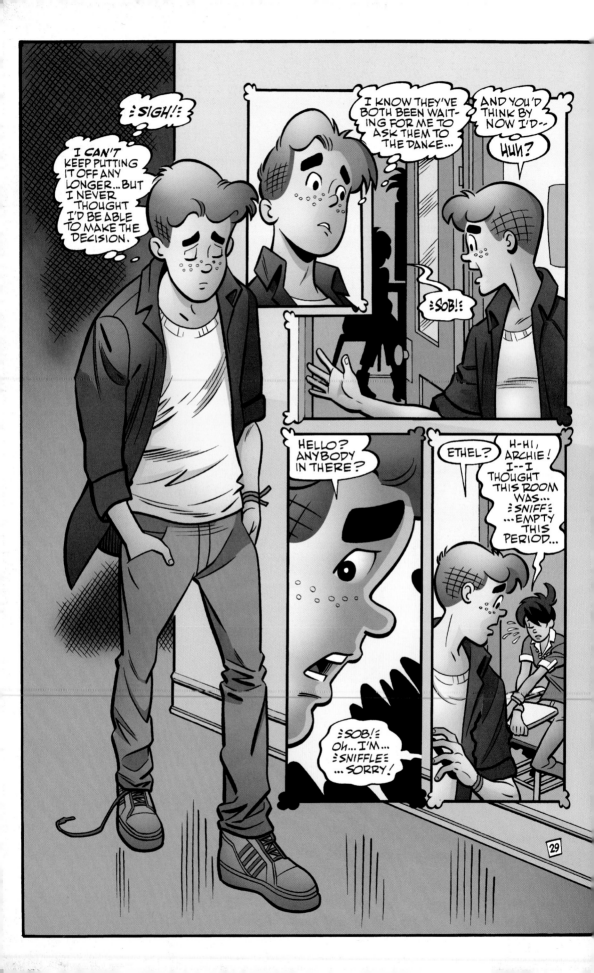

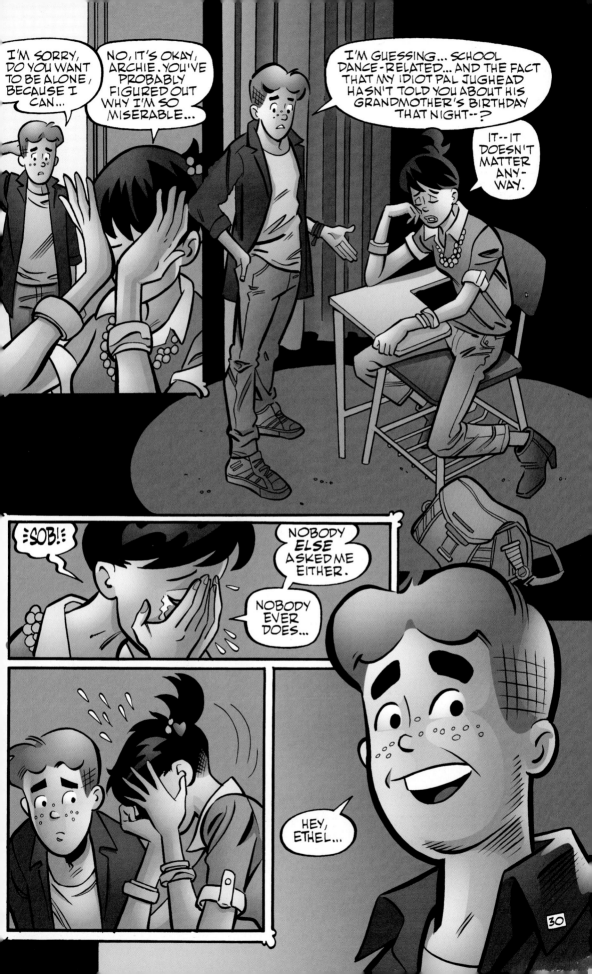

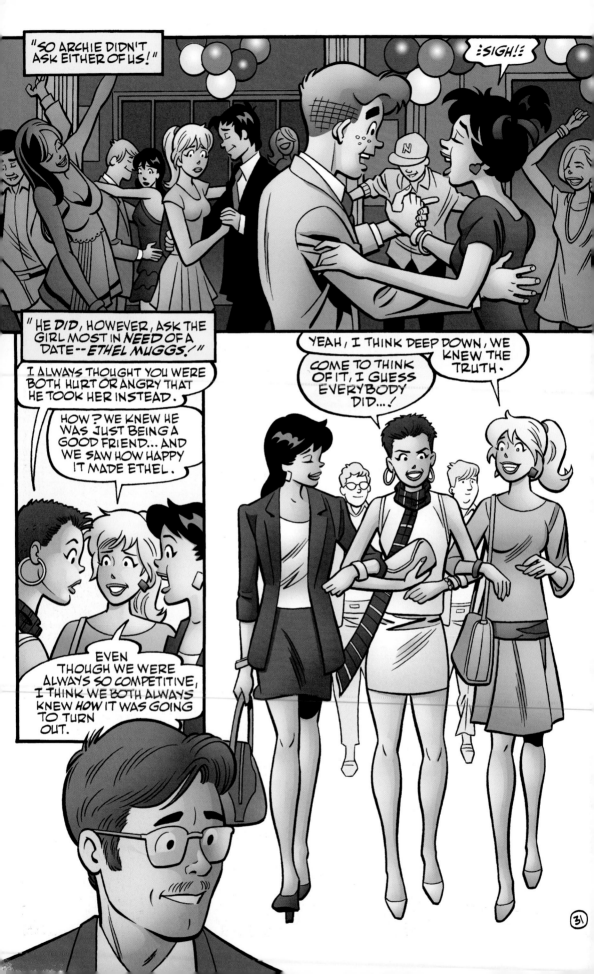

"SO ARCHIE DIDN'T ASK EITHER OF US!"

:SIGH!:

"HE *DID*, HOWEVER, ASK THE GIRL MOST IN *NEED* OF A DATE-- *ETHEL MUGGS!*"

I ALWAYS THOUGHT YOU WERE BOTH HURT OR ANGRY THAT HE TOOK HER INSTEAD.

HOW? WE KNEW HE WAS JUST BEING A GOOD FRIEND... AND WE SAW HOW HAPPY IT MADE ETHEL.

YEAH, I THINK DEEP DOWN, WE KNEW THE TRUTH.

COME TO THINK OF IT, I GUESS EVERYBODY DID...!

EVEN THOUGH WE WERE ALWAYS SO COMPETITIVE, I THINK WE BOTH ALWAYS KNEW *HOW* IT WAS GOING TO TURN OUT.

31

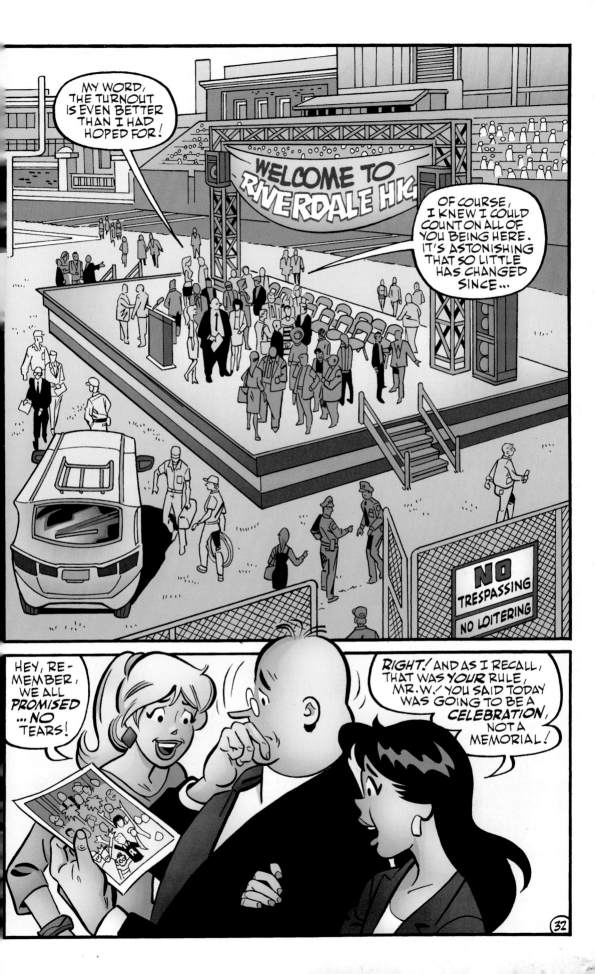

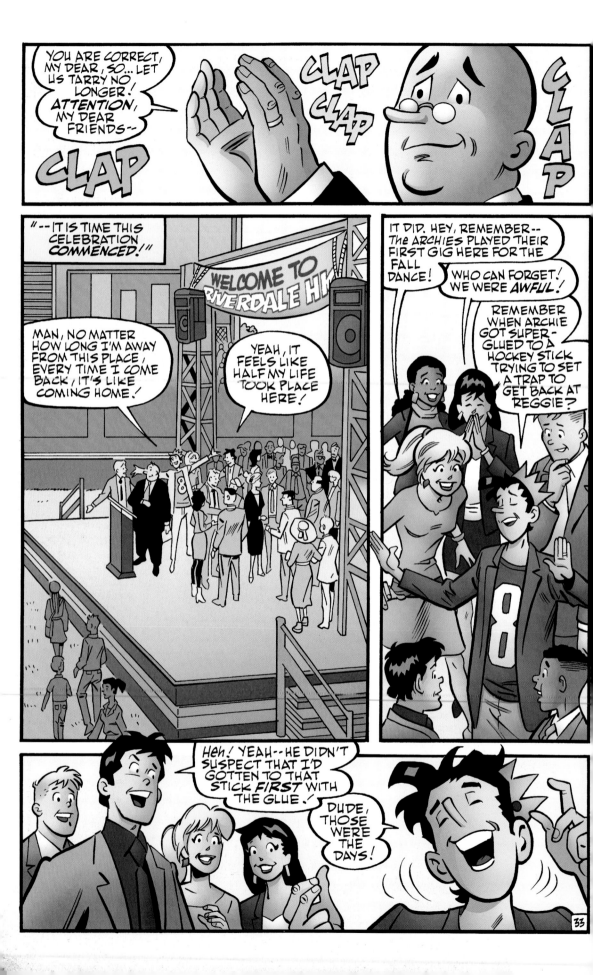

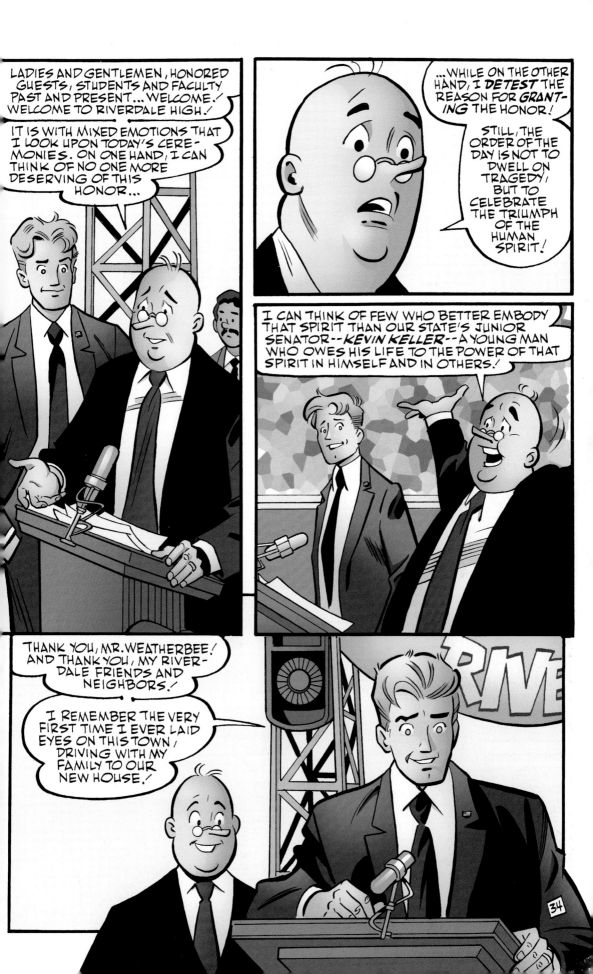

LADIES AND GENTLEMEN, HONORED GUESTS, STUDENTS AND FACULTY PAST AND PRESENT... WELCOME! WELCOME TO RIVERDALE HIGH!

IT IS WITH MIXED EMOTIONS THAT I LOOK UPON TODAY'S CEREMONIES. ON ONE HAND, I CAN THINK OF NO ONE MORE DESERVING OF THIS HONOR...

...WHILE ON THE OTHER HAND, I *DETEST* THE REASON FOR *GRANTING* THE HONOR!

STILL, THE ORDER OF THE DAY IS NOT TO DWELL ON TRAGEDY, BUT TO CELEBRATE THE TRIUMPH OF THE HUMAN SPIRIT!

I CAN THINK OF FEW WHO BETTER EMBODY THAT SPIRIT THAN OUR STATE'S JUNIOR SENATOR -- *KEVIN KELLER* -- A YOUNG MAN WHO OWES HIS LIFE TO THE POWER OF THAT SPIRIT IN HIMSELF AND IN OTHERS!

THANK YOU, MR. WEATHERBEE! AND THANK YOU, MY RIVERDALE FRIENDS AND NEIGHBORS!

I REMEMBER THE VERY FIRST TIME I EVER LAID EYES ON THIS TOWN, DRIVING WITH MY FAMILY TO OUR NEW HOUSE!

34

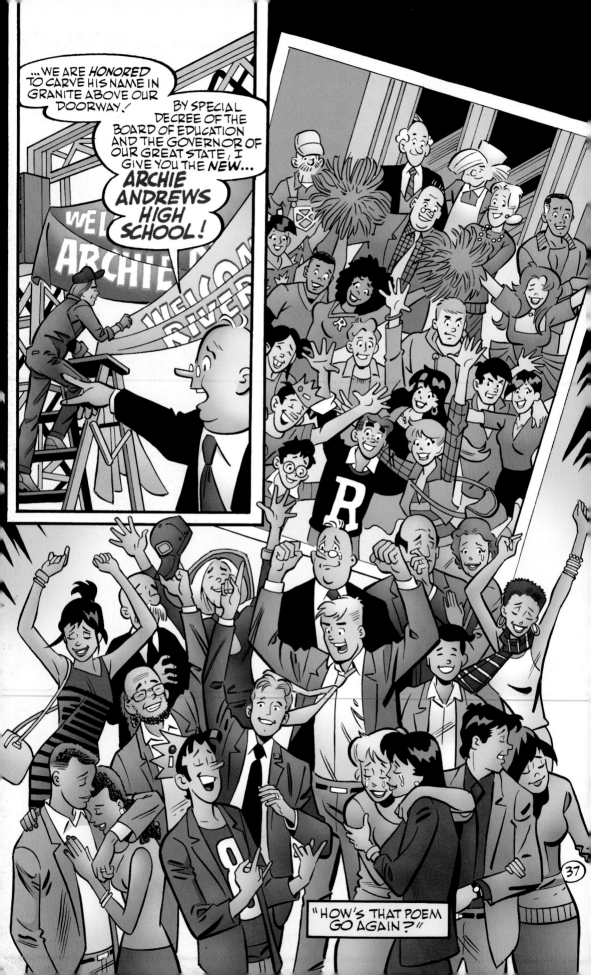

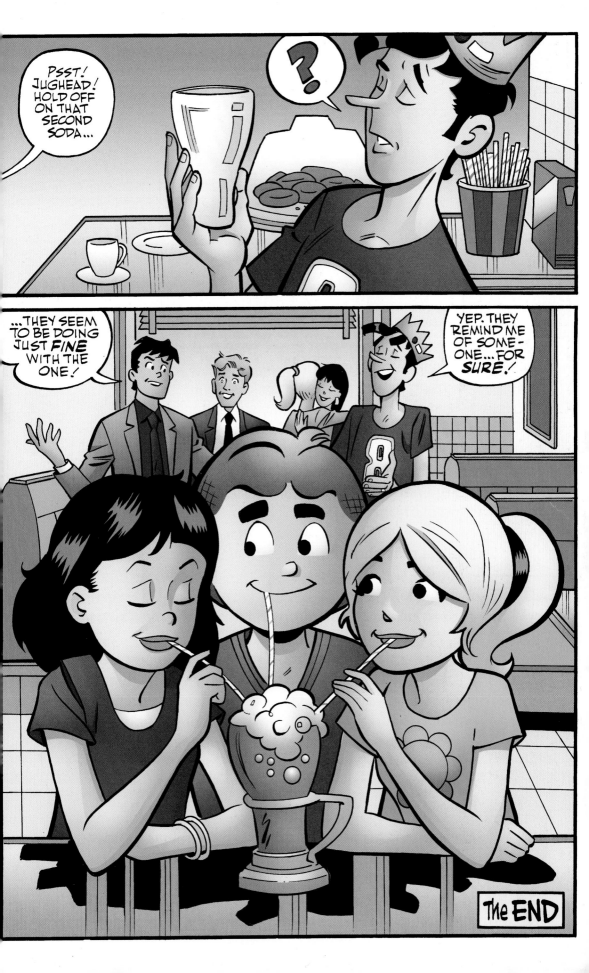

THE DEATH OF ARCHIE

AN AMERICAN ICON: THE BEGINNING

It's strange to think that there was ever a time when Archie wasn't around, either on the checkout line at your local grocery store, on your television each Saturday morning or at your local comic shop or bookstore—but it's true. Before Archie's introduction in 1941 in the pages of PEP COMICS #22—a comic book previously filled with funny animal, monster and superhero stories—there was just a company with a different name and three founders looking for a way to stand out from their comic book publishing competitors.

Initially a publisher of pulps and eventually superhero comics like "The Shield" and "The Hangman," the comic book company that became Archie Comics was first named MLJ—an acronym formed from the initials of the company's three founders, Maurice Coyne, Louis Silberkleit and John L. Goldwater. The company evolved from the pulps to publishing a slate of various genres, filling anthology series with stories about noir-ish detectives, jungle adventures, superheroes and more. But it was the sudden, somewhat subdued first appearance of an awkward-looking carrot-topped teenager that forever altered the course of the company. But we're getting ahead of ourselves.

The idea for Archie—an everyman character who would exist in stark contrast to the crime-fighting avengers dominating a large portion of the market—came to Goldwater in a sketch. The MLJ founder reasoned that if a "super man" could sell copies, how much more would an "every man" appeal to readers?

The character reminded him of an old high school friend—a likable sort who was mischievous but good-natured and the object of two girls' affections. Goldwater very smartly inverted the "boy chases girl" cliché and doubled it, creating the basic structure for one of the most legendary love triangles in the history of pop culture—the affable Archie, eternally caught between the kind-hearted Betty and the wealthy Veronica. Goldwater also added another twist to the already compelling dynamic by making Archie's two suitors not only competitors for his attention, but also BFFs.

With the pieces in place, Goldwater took the basic premise to one of MLJ's cartoonists, Bob Montana. Just 17 at the time, the artist was instantly drawn to the comedic aspects of the story, and started bringing the characters—now expanded to include the detached foodie Jughead and the egomaniacal Reggie—to life with Goldwater, setting the foundation for Archie and his friends that lives on to this day.

Funny enough, Archie didn't even appear on the cover to his first appearance—the aforementioned PEP COMICS #22—in a story drawn by Montana and written by Vic Bloom. But that didn't stop the character from grabbing hold of his audience's attention. By the time Veronica Lodge made her debut in PEP COMICS #26, the eternal love triangle had fallen into place—and Archie began his methodical rise to super-stardom, first by making PEP a top-seller and then onto his own comic book in the winter of 1942.

A year later, Archie's influence had spread to other media, with the launch of a national radio program that would run for a decade, followed by a hit newspaper strip by Bob Montana in 1946. That was the same year the company formally changed its name from MLJ to Archie Comics, confirming Archie's role as the flagship character and brand. In a very short time, Archie had made an indelible impression on the American public and would prove to be the most enduring teenage property in U.S. history.

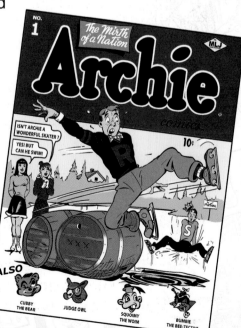

BEYOND COMIC BOOKS

Over the next two decades, Archie continued to evolve under the stewardship of some of the greatest comic book writers and artists in the history of the medium, including the witty and sharp scripters Frank Doyle and George Gladir and the artistic mastery of Harry Lucey, Dan DeCarlo, Samm Schwartz and Bob Bolling. And while the influence the comics had can never be understated, it was a Saturday morning Archie cartoon that shot the character to new heights.

In the early '60s, music and TV producer Don Kirshner found himself basking in the glow of his latest creation, the hit Monkees television show and band. Offering the group a new song he deemed a surefire hit, Kirshner was surprised when they passed. Unwilling to let the song fade away, especially one he saw as a guaranteed smash, Kirshner took inspiration from the Archie comics his kids were reading—

specifically an issue of LIFE WITH ARCHIE featuring Archie's pop band, The Archies. The show formed in his mind—it would be about the characters and their band and feature new music that would enthrall the pop-conscious teenagers making inroads as the medium's most important demographic. Working in collaboration with an ambitious young CBS executive named Fred Silverman and the fledgling animation studio Filmation, Kirshner helped to create the bright, fast-paced musical comedy cartoon *The Archie Show* that dominated Saturday mornings. The music, featuring Archie vocals by Ron Dante, proved to be such a success that The Archies' songs began hitting the radio airwaves and climbing the pop charts.

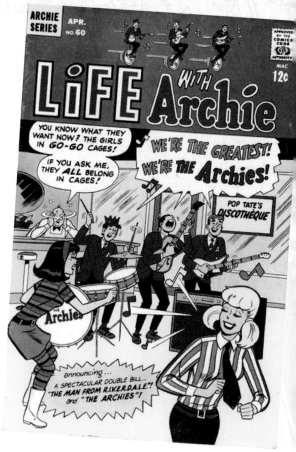

In 1969, The Archies found success during one of the most competitive musical seasons ever, with the number one song of the year, "Sugar, Sugar" beating out The Beatles, the Rolling Stones and the Supremes. The group continued to chart albums and singles well into the '70s.

The popularity the cartoon bestowed upon Archie and his friends mushroomed into other media and licensing opportunities in the '70s and '80s, with Archie's smiling face on everything from toys to posters to apparel— and beyond. Archie was showing up in places he'd never been before.

That, paired with the birth of comic book retail stores and comic-themed conventions saw Archie maintain his presence in the pop culture landscape, putting the character in the unique position to appeal to dedicated comic fans and a more general audience.

While the characters retained the sensibilities and traits Goldwater and Montana imbued them with, change was still part of the Riverdale landscape—including new characters. The most notable addition to the gang in the '80s—at least as far as Archie was concerned—was the sultry rich girl Cheryl Blossom, who rivaled Betty and Veronica for Archie's affections.

Archie also had the honor of being part of one of the most talked-about and memorable inter-company comic book crossovers in ARCHIE MEETS PUNISHER, which saw Marvel Comics vigilante the Punisher head to Riverdale and cross paths with the lovable redhead in a hilarious and surprising one-shot often cited as the wackiest comic book crossover of all time.

The "Archie Marries…" saga, ended up garnering even more publicity than that milestone event. The initial mini-series spawned an ongoing, magazine-size periodical—dubbed LIFE WITH ARCHIE—that featured the work of writer Paul Kupperberg and a variety of artists over its run including Norm Breyfogle, Pat Kennedy, Tim Kennedy, Fernando Ruiz, Joe Rubenstein, Bob Smith, Jim Amash, Al Milgrom, Andrew Pepoy, Jack Morelli, Janice Chiang and Glenn Whitmore.

Dan DeCarlo

A VIBRANT, EVOLVING BRAND

LIFE WITH ARCHIE was the flagship title of what many industry analysts dubbed "The New Archie," under the watchful eye of Publisher and Co-CEO Jon Goldwater, son of original founder John L. Goldwater. Goldwater's ability to take risks and push the envelope while still being mindful of the true essence of each character—as seen in the introduction of gay character Kevin Keller, who became a media sensation, and the launch of the hit zombie series AFTERLIFE WITH ARCHIE—revived the Archie character and brand, leading to the strongest awareness of the character in the last 30 years and a further expansion in other media.

In fact, this very book you hold in your hands was probably the clearest example that Archie remains on the pop culture radar, with worldwide press and fandom reacting to the news of the character's death in a historic fashion. From the pages of daily newspapers to the evening news to *Saturday Night Live*, Archie's possible final moments were a hot topic of conversation.

And this is only the beginning.

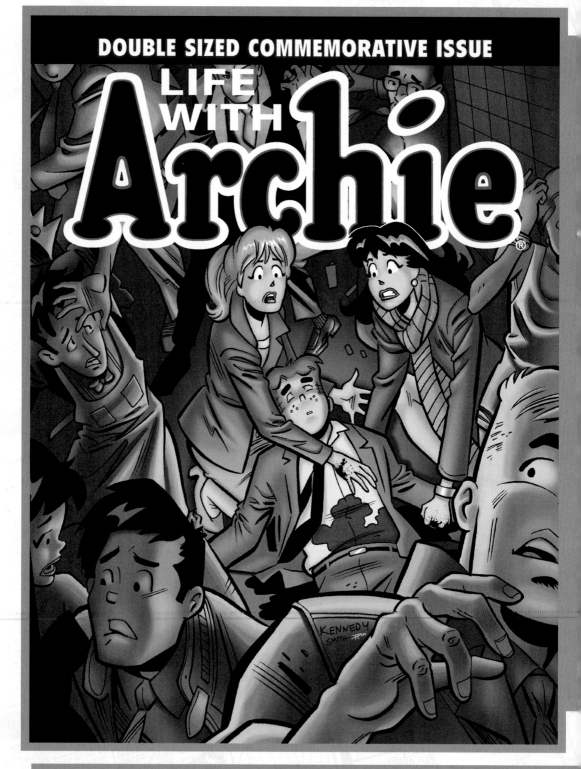

DOUBLE SIZED COMMEMORATIVE ISSUE

LIFE WITH Archie®

"We didn't see that one coming. The DEATH OF ARCHIE proves that the Married Life books always leveled up the expectations any readers of Archie comics had. Paul Kupperberg's scripts brought a new dimension to these familiar characters. What a great experience."

- Pat & Tim Kennedy

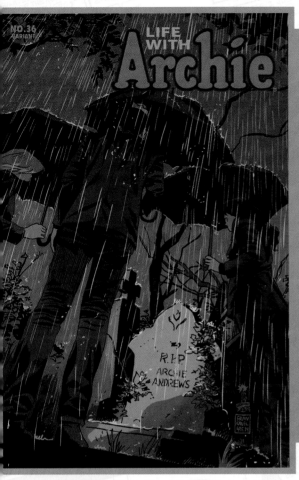

"As soon as we decided on having multiple variants for the Death of Archie, there was no question that we wanted to have art from the enormously talented Francesco Francavilla. From his work on one of the most notable variants we've published on this very title in LIFE WITH ARCHIE #23 to his art in AFTERLIFE WITH ARCHIE—both of these, in addition to this finale, were all ideas that came from the mind of the intrepid Jon Goldwater—it is clear how expertly he can depict a somber and striking scene, and this cover is no exception."

- Mike Pellerito
President, Archie Comics

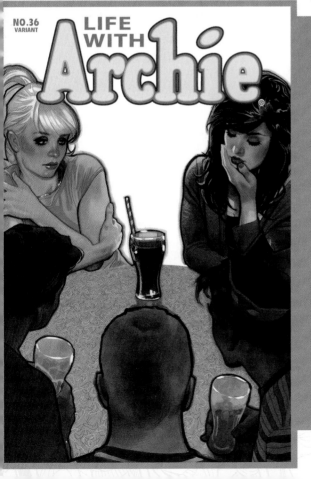

"Great! My first-ever **ARCHIE** cover and Archie's nowhere to be seen. This may be the saddest drawing I've ever done. I felt like doing a nice, cheerful **PUNISHER** cover afterwards. It always takes me several covers to figure out how I should draw a character or characters. Having my first ARCHIE cover be such an important one, filled with gravitas, did not help! Somehow I got it done. Godspeed, Waffle-head. Godspeed."

- Adam Hughes

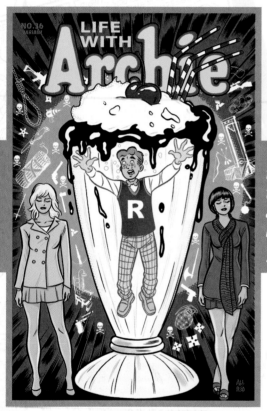

> "The Death of Archie isn't something I ever expected to witness, but what a fitting way to end a serious and dramatic series! I've done some covers featuring the rock bands of Riverdale in the past, so I thought I'd continue the theme for this image—The Archies minus their frontman."
> - Fiona Staples

> "I feel a bit odd saying that I had a great time doing my first Archie drawing around the circumstances of his death. But it was a great time. He's such a giant icon and it was a huge thrill to do the cover."
>
> - Michael Allred

The death of someone close is never a happy thing. Everyone we share our lives with we leave an impression on, a small thumbprint, for better or worse.

- Ramón K. Pérez

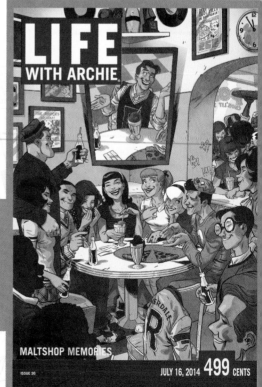

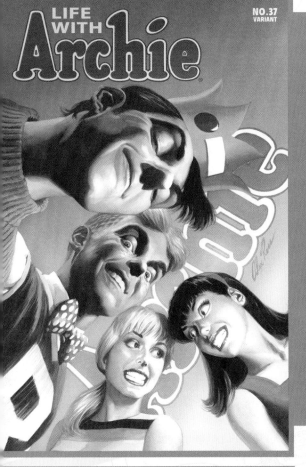

"Having Alex Ross do a cover for Archie was like a dream come true. His painted art is not only award-winning, but his images are so memorable it was a no-brainer that we wanted him to be a part of this historic finale. The final product is one that is sure to withstand the tests of time along with his many memorable covers."

- Mike Pellerito
President, Archie Comics

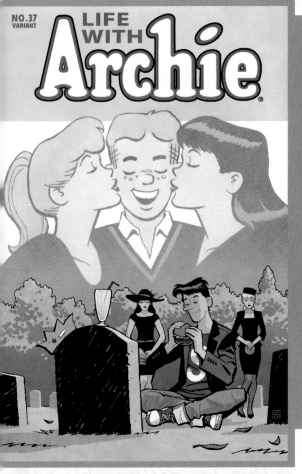

"As a fan, it was important to me to balance the solemnity of the occasion with some of the humor and life that Archie Comics are known for. While the resting crown hat on the tombstone is a signal to move on and grow up, I thought Jughead would also try to celebrate his best friend's memory the only way he knows how: with a burger and malt shake. It's a quiet, private moment between friends. Pour one out for Archie Andrews!"

- Cliff Chiang

"When I was approached by Archie Comics about drawing one of the covers for the Death of Archie, I gave the matter some serious thought. The books have always centered around the Archie/Betty/Veronica relationship. I wanted a simple image, emblematic of that now sundered relationship between the three."

- Walter Simonson

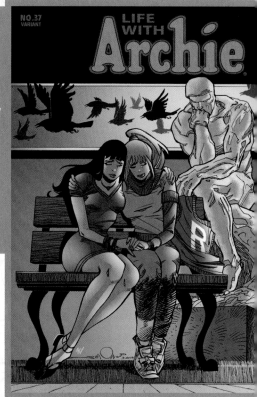

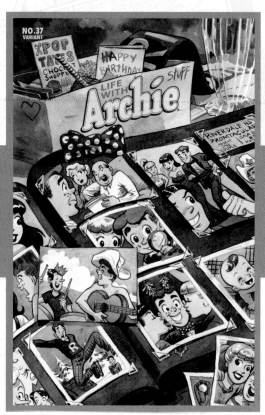

"We love having Jill Thompson's ar on our covers as much as we can. It was a pleasure having her be a part of this momentous occasion."

- Mike Pellerito,
President, Archie Comics

"I've always wanted to draw the Archie characters. It was quite an honor to try to tap into the emotional loss Betty and Veronica are wrestling with in this story."
- Tommy Lee Edwards

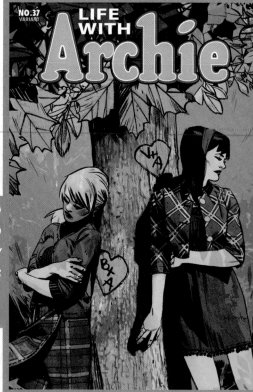

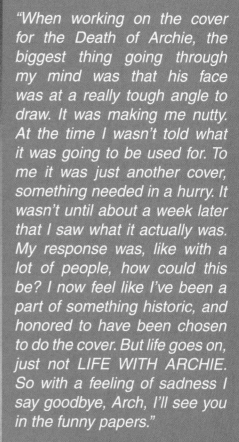

THE DEATH OF Archie

A LIFE CELEBRATED

"When working on the cover for the Death of Archie, the biggest thing going through my mind was that his face was at a really tough angle to draw. It was making me nutty. At the time I wasn't told what it was going to be used for. To me it was just another cover, something needed in a hurry. It wasn't until about a week later that I saw what it actually was. My response was, like with a lot of people, how could this be? I now feel like I've been a part of something historic, and honored to have been chosen to do the cover. But life goes on, just not LIFE WITH ARCHIE. So with a feeling of sadness I say goodbye, Arch, I'll see you in the funny papers."

- Jeff Shultz

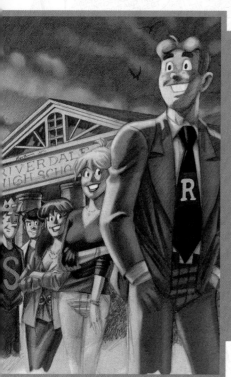

"As an Archie fan as well as an Archie artist, I always found myself looking forward to each new script just to see where the story was going to go and what was in store for the characters. The series was a big roller coaster of dramatic changes and big events. It seems right to say goodbye with a nice, quiet moment. After Archie sheds this mortal coil, I like to think that he gets to spend his eternity in the place that meant the most to him and where he had his wackiest adventures—his beloved Riverdale High. I'm happy to be able to send him off with this cover where he's surrounded by his friends!"

- Fernando Ruiz

THE DEATH OF Archie

A LOOK BEHIND THE SCENES

Putting together the Death of Archie was no small task. It is thanks to the tireless work of our talented writer, artists and staff that we are able to present to you these two historic final issues of LIFE WITH ARCHIE. We hope that you've found them to be impactful and memorable. Here at Archie Comics, we always strive for excellence in each issue that we publish but, especially for a finale so under the microscope, we really wanted to go above and beyond in our presentation of this momentous event. In order to make this possible, there had to be many drafts and revisions of each page.

Fortunately, our intrepid artists were up to the task, and worked painstakingly on each page and panel, making every art revision asked of them until the perfect, finalized versions were reached. These next few pages will give you a detailed, insider's look at the art process behind the final issues of LIFE WITH ARCHIE and what important changes were made on some of the most significant pages of the two final issues.

Keep in mind that some of these images may have still gone under more revisions as they went on to the ink and color stages, but this is a close look at some of the motives behind the revisions for the initial penciled images.

We hope you enjoy this look behind the scenes of the Death of Archie.

ORIGINAL

In this first draft, a shadowy hand with a gun pointed directly at a fear-stricken Archie is visible.

A shocking image, yes, but it was still not quite as clear as it needed to be for such a hugely significant moment. In order to truly make this panel stand out, a few revisions were needed—especially revisions to the shooter's hand and the gun.

This action shot needed to be as clear and accurate as possible for maximum impact.

REVISED

In this revised penciled image, we can now very distinctly view the gun—including a well-defined action shot of the gun recoil, with the slide kicking back for optimal accuracy.

We can also see a more distinct version of the shooter's arm, hands and fingers, with his index finger pulling the trigger as it blasts toward Archie.

A striking image from the get-go, this panel has now been made even more realistic.

This page went through quite a few changes from its first inception to the final incarnations shown below.

Initially packing a lot of action onto one page, it was decided that it should be instead split up into three heart-wrenching and provocative pages.

In this image, the focus is on Betty and Veronica's initial reaction, with a more tragic close up of the recently-shot Archie's last few moments of life. His expression changed to a more solemn one, with a pool of blood visible on his mouth.

A whole page was dedicated to the tearful reactions of Archie's two loves, Betty and Veronica. Just one panel of the two crying, with Archie's last words appearing between them, surrounded by black to strike a more somber note.

This page presents the last time we will ever see the adult Archie Andrews in LIFE WITH ARCHIE. It was pertinent that this final view of Archie be one that hits an emotional chord in the reader. Surrounded by his tearful friends, this image is meant to also bring a tear to the eye of any reader—who, like all those at Pop Tate's—is also losing a longtime friend. In order to make the last image of Archie resonate with readers, a few corrections to his illustration were needed.

As you can see, the main changes to this page were in Archie's placement. Slightly awkward in the original pencils, his legs are now positioned in such a way that evokes less of a "fallen over" image and more of Archie in a slumped over, helpless state, with his legs next to each other and his palms facing up. Most importantly, he is no longer just lying on Jughead's lap, but instead Jughead is embracing him, and supporting him one last time.

If there's any one, single image that will surely be ingrained in readers' minds for a lifetime, it is the final page of the issue. The three-on-a-soda image is surely one of the most iconic images in Archie history. This illustration harkens back to a simpler time, a time where Archie was synonymous with milkshakes, sock hops and being fun and fancy free. To see this iconic and often-happy image distorted is more than just a spilled milkshake—it's representative of an entire world being turned upside down.

ORIGINAL

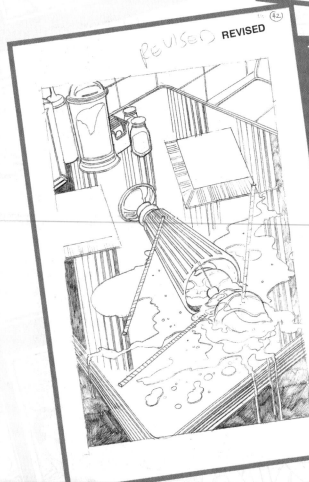

REVISED

There wasn't much that needed to be changed on this page in terms of art. The only note was to remove the box that previews the next chapter of the series. Every issue previously has had a text box that states what the next story title is, but this last page needed to be different from all the rest. This revision was also made because it was felt that the text box obscured the art, and it was important to let this unforgettable image speak for itself.

Our story ends on a much happier note, indicating a much brighter future for Riverdale. Life is cyclical in nature, and when one life and love ends, others are sure to begin. Earlier in this issue, we see some flashbacks of Archie throughout his life. We are reminded of the good times we had with our ginger friend. Now, a year after the tragedy, it is time to move on—but moving on is in no way the same as forgetting. Here we see three familiar-looking kids, not the same as the ones we know, but very similar.

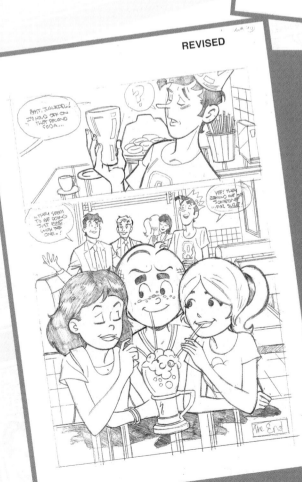

The changes made are fairly obvious: we wanted the kids to be reminiscent of Archie, Betty and Veronica. In the first pass, it is clear who they were supposed to represent, but the kids were a tad too far off from the love triangle we're all familiar with. In the revision, their hair styles are much closer to Archie, Betty and Veronica's. But we still didn't want them to be TOO eerily similar, so some changes were applied. As you'll notice in the final, inked and colored version, pseudo-Archie's freckles have been removed, so there's no confusion.